IMAGES
of America

MERIDIAN

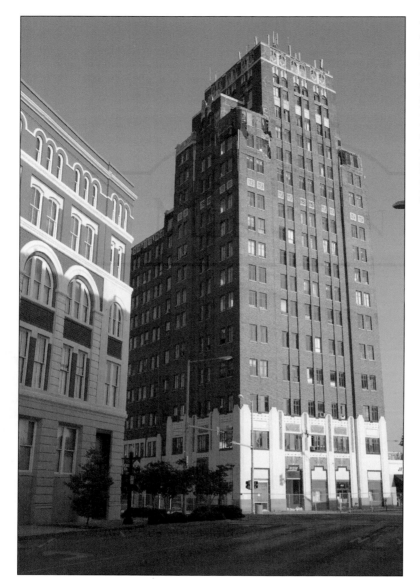

The 16-story Threefoot building, a Meridian landmark, was erected in 1929 during the Great Depression. It was built by the Threefoot brothers, H. Marshall, Kutcher, and Lewis. (Courtesy of the *Meridian Star*.)

ON THE COVER: On the corner at left is the First National Bank at 500 Fifth Street. Leibel Jewelry is thought to have been owned by Joseph C. Leibel. Joseph and his son Bryant were both local jewelers. Across the street are the Cinderella Slipper Shop, Woolworth's Five and Dime, and the Martin Dickson Drugstore. Ben H. Dickson was a Meridian druggist in the 1920s and 1930s. (Courtesy of William Hooper of Saenger Amusement.)

IMAGES
of America

MERIDIAN

June Davis Davidson

ARCADIA
PUBLISHING

Published by Arcadia Publishing
Charleston, South Carolina

Printed in the United States of America

Library of Congress Control Number: 2011936322

For all general information, please contact Arcadia Publishing:
Telephone 843-853-2070
Fax 843-853-0044
E-mail sales@arcadiapublishing.com
For customer service and orders:
Toll-Free 1-888-313-2665

Visit us on the Internet at www.arcadiapublishing.com

*It is with considerable pleasure that I dedicate this brief history
and pictorial of Meridian to the people of Lauderdale County
and to my children—Brent, Grey, April, and Susan—and
my grandchildren—Marilyn, Katie, Dalton, Lindsey,
Cade, Cortney, Will, Cole, Cameryn, and Claire.*

This journey into the pages of history has been a rewarding experience.

CONTENTS

Foreword 6

Acknowledgments 7

Introduction 8

1. The Early Years 13

2. Railroads and Transportation 47

3. Timber and Manufacturing 55

4. Parades and Entertainment 67

5. Important Events 83

6. Communities of Lauderdale County 105

FOREWORD

Within the pages of *Meridian*, readers can actually see the store their great-grandmother shopped in or the mill where their great-uncle worked. They can imagine walking beside the streetcar on Fifth Street and attending the latest show at the Grand Opera House.

June Davis Davidson's photographs and text transport you to a time of horses and buggies and Model Ts, when the railroad ruled and cotton was king. Her photographs allow you to see what you never experienced. Her words give voice to each silent picture.

Many cultures have carved their stories into the hills, valleys, and piney woods of Lauderdale County, a land as rich as the state it lies in. Yes, there is something about Meridian that draws people—something so strong that even those who live here ponder and question its magnetism. This is a book you will come back to time and time again, and one to always keep within reach.

—Richelle Putnam

ACKNOWLEDGMENTS

It is with deep appreciation that I thank the *Meridian Star*, Ward Calhoun and the staff of the Lauderdale County Department of Archives and History, Dorothy Hagwood, and Emma Lou Price. Thanks go to my support team: my acquisitions editor, Ellen Babb; my daughter Susan; my husband, Bobby; Dean Davidson; and Richelle Putnam for their unwavering faith and encouragement through this journey. A special thanks to Virginia Irby, Doris Welker, Joanne and Lynn Culpepper, Glenda Hughes, Johnny Hughes, Doris Irby, Mattie Lou Downey, and the many individuals who graciously gave of their time and photographs. Without these lovers of history, this pictorial record of Meridian and Lauderdale County would not have been possible.

INTRODUCTION

The fresh scent of virgin pine filled the air, and a soft blanket of foliage covered the ground at the crest of the hill. Below, white-tailed deer loped across a lush green meadow that beckoned, waiting for a city to rise up among its midst, and in 1831, Richard McLemore answered its call. McLemore became the first white settler on the land once occupied by the Choctaw.

Meridian, once known as Sowashee, owes its early existence to McLemore, who secured a 2,000-acre land grant. It is thought that perhaps McLemore originally intended to offer pioneers free land to come settle this valley near the Sowashee Creek. Perhaps it was with foreknowledge or expectation of a future railroad through Sowashee that an Alabama lawyer, Lewis A. Ragsdale, purchased a large portion of McLemore's property. Another entrepreneur, John T. Ball, a merchant from Kemper County who purchased McLemore's remaining acreage, joined McLemore and Ragsdale.

When the Mobile & Ohio Railroad (M&O) came to Sowashee in 1855, Ball built a flag station on the rail line. It was during this period that a disagreement erupted over Sowashee's name. Lewis Ragsdale favored the name Ragsdale City, while John Ball held the opinion that Meridian would be a more appropriate name. Legend has it that the sign on Ball's station house on the M&O changed daily from Sowashee to Meridian. Ball settled the conflict when his request was granted to establish a post office in his log store on the corner of Twenty-sixth Avenue and Seventh Street, and he registered the post office's name as Meridian. At the time, Meridian was the second largest town in Lauderdale County, after Marion, which was established in 1833. The county was named in honor of Col. James Lauderdale, who fought in the Battle of New Orleans.

Meridian's triangular streets are thought to be part of Ball and Ragsdale's vision for the small village, when both men simultaneously attempted to chart the city streets on their prospective land. It is said that when McLemore sold his home and farm in Meridian and moved into the country, Ragsdale bought the McLemore house and turned it into a saloon. The saloon was not the only place visitors could wet their whiskers, since the county's mineral springs enticed visitors to partake of the pure waters.

Before the Civil War, health spas and resorts sprang up in Lauderdale Springs and Lithia-Arundel Springs. A hack line transported tourists to the county's springs that were touted to cure various ills. The resort at Lauderdale Springs served as a Confederate hospital during the Civil War and later became a refuge for the orphaned children of Confederate soldiers.

Fifteen families resided in Meridian when the Civil War erupted. Meridian became the capital of Mississippi for a short time when William Tecumseh Sherman invaded Jackson, though he later seized Meridian. Some historians claim that the Confederate Army destroyed the railway and arsenal before abandoning Meridian. However, the destruction of the Confederate arsenal and railway system, both of which were crucial to troop and ammunition transportation, is credited to Gen. William Tecumseh Sherman and his troops.

The invasion ended in February 1864, when General Sherman lit a torch and burned Meridian. After the war, the rail system was rebuilt, and Meridian rose from its ashes. Later, the race riot brought about by Reconstruction in 1871 was one of Meridian's bloodiest times. In an 1882 article by W.G. Grooms, he wrote about the years 1869 through 1871 and the riot that ensued as, "days of oppression, days when the people lived in almost constant dread of some sort of harm to person or property; days when an incubus pressed heavily upon their souls." Then-mayor William Sturgis remained in office from 1870 to 1871 and was thought to be the instigator of the race riot. He

ignored numerous attempts by the city's residents to have him removed from office. After the riot, Sturgis was barred from the town, and its citizens safely placed the unwilling mayor on a northbound train. Meridian's reconstruction began after the riot, when people of both races lived peacefully within the boundaries of the growing village.

After Meridian incorporated on February 10, 1860, it became the county seat seven years later. The growth in the timber, manufacturing, and cotton industries was directly related to the flourishing railway system, and Meridian had grown to be the largest city in the state by 1930.

However, Meridian would have many obstacles to overcome in the intervening decades. Fires plagued the city, and the clang of the bells on horse-drawn fire wagons was a frequent sound after Meridian established its first hook and ladder fire department. The city infrastructure improved, and the blocks of wood that once paved the streets gave way to brick. Colleges sprang up—the male college, the female college, the medical college, an African American college, and the Music Conservatory. Transportation to the colleges was provided by a network of trolley cars that ran throughout the city to the outskirts of town. Timber mills, cotton mills, and manufacturing plants dotted the landscape as Meridian grew and prospered.

The streets were congested with ox-drawn wagons loaded with cotton, and the neighing of horses filled the air as hooves pounded against the blocks of wood that lined the street. In the distance, the echo rang out of an anvil striking red-hot iron, momentarily clashing with loud voices at Meridian Cotton Press, where workers loaded bales of cotton onto wagons for shipment by rail. A short distance away, plumes of steam rose over the depot as travelers departed the M&O train to enjoy culinary cuisine at the St. Elmo or Elmira Hotel Restaurant before settling down for a night's rest.

Travelers arrived in Meridian (the largest city in the state from 1890 to 1930) by train or horse and buggy, and they could lodge at the European House (established around 1870), St. Elmo Hotel (established around 1880), the Meridian Hotel (established around 1909), the Elmira Hotel, or the Grand Avenue Hotel, which was destroyed by the March 2, 1906, tornado.

No sooner had Meridian recovered from Sherman's torch than the town faced another enemy, the yellow fever epidemic of 1878, which was spread by mosquitoes that thrived in stagnant water. When cotton prices plummeted, the city turned to the vast virgin pine forest in Lauderdale County.

Men of the Jewish faith and their families moved from Marion Station to Meridian and, in 1873, built its first synagogue in the city. Many Jewish immigrants rose to prominence during the late 1800s and early 1900s. During Meridian's golden age (1890–1930), a group that included half-brothers Isaac A. Marks and Levi Rothenberg commissioned Swedish architect G.M. Torgenson to build the Marks Rothenberg department store and the adjoining Grand Opera House. The Grand Opera House opened in 1890, a time when wooden buildings had been banned in the business district due to the growing number of fires, but another destructive force soon descended on Meridian.

Before the chill of winter turned into spring, on the second day of March 1906, ominous gray skies hovered over Meridian as the business day drew to a close and the bustle of activity quieted. Peace soon gave way to terror when a deadly cyclone from the east destroyed much of downtown Front Street. It is said that Meridian rebuilt so fast that one would not recognize it within a year's time. Businesses flourished; timber, cotton, and manufacturing grew; and Meridian became known as the largest and most progressive city in the state.

Meridian Light and Railway serviced Highland Park, which was located on donated land. Parks were sometimes referred to as pleasure parks. A trolley car ran from downtown to the park, where visitors could enjoy shaded walks. In the early years, a trolley ran from Eighth Street to Highland Park's trolley station, where an amphitheater, dance pavilion, bandstand, and botanical garden were added. The city purchased a hand-carved Dentzel carousel after the 1904 St. Louis Exposition. The Dentzel carousel arrived in Meridian in 1909, when the Mississippi State Fair was held at the park.

As the 19th century transitioned into the 20th, Meridian continued to grow and prosper. Successful businessmen built magnificent homes, and the city began its long history in the arts.

H. Marshall, Kutcher, and Lewis Threefoot envisioned Meridian's first skyscraper, an Art Deco–style building, and construction began in 1929 on what became a landmark of Meridian's skyline. Cotton mills dotted the landscape in the south end of town, and some mills employed children under the age of 12. Ladies from the Wesley House taught homemaking and sewing to the wives of mill workers. Meridian's growth slowed during the Great Depression.

Meridian was thrown into the national news in the following decades. One such incident occurred five years after Emil Mitchell was named "King of the Gypsies" in 1910, according to a *New York Times* article dated July 10, 1910.

Less than five years later, the Romani Gypsy caravan camped near Coatopa County, Alabama, while Emil's wife, the 47-year-old queen, Kelly Mitchell, labored to give birth to her 16th child. Legend has it that the Gypsy king summoned a country doctor and offered him $10,000 to save the life of his dying queen and unborn child. The doctor labored in vain, and on January 31, 1915, the Gypsy queen and unborn child died.

Her body was brought to Meridian, a city with enough ice to preserve her until Gypsies could be summoned from across America. As the Gypsies arrived, Meridian's population swelled to 40,000. The queen's body was brought to the Horace C. Smith Undertaking Company in Meridian.

The Gypsy queen's funeral was held at St. Paul's Episcopal Church. The funeral procession followed King Emil's horse-drawn carriage behind the queen's glass-encased, horse-drawn hearse to Rose Hill Cemetery, where it is reported that over 5,000 gypsies attended the graveside service. Local legend tells of gold coins being tossed into her grave. Over the years, attempts have been made to rob her grave, without success. Gypsies still visit the queen's grave and leave gifts of food and trinkets. Since the time of Emil and Kelly Mitchell, Rose Hill has become a burial ground for the Mitchell Gypsy clan.

Jimmie Rodgers, known as the "Singing Brakeman," rose to fame in the early 1900s and died in his New York hotel room in 1933, a victim of tuberculosis. The Jimmie Rodgers Festival, organized in 1953, brought well-known Nashville singers to Meridian's Temple Theater stage to honor the "Father of Country Music." A museum honoring Rodgers is located in Highland Park.

Meridian, established as a home for arts and entertainment, entered the silent-movie era with the opening of theaters like the Temple and the Princess (with its mechanical roof), and as the popularity of movies grew, other theaters followed within the next few years, such as the Roberta, the Royal, the Ritz, and others that dotted the downtown landscape. The eyes and ears of the world would soon focus on two pioneering aviators from Meridian.

Fred and Algene ("Al") Key lifted off on June 4, 1935, in a borrowed Curtiss Robin monoplane named *Ole Miss* and flew into aviation history. With the help of local mechanic A.D. Hunter, the three designed the refueling system used to transfer fuel. Pilots James H. Keeton and Bill Ward, two barnstormers from Alabama, flew the refueling aircraft that transferred fuel in flight to the Key brothers' plane, proving that safe, in-flight refueling was possible. On July 1, 1935, the Key brothers landed the *Ole Miss* (owned by Bill Ward) to a cheering crowd of 25,000 gathered at Key Field in Meridian. Following the flight, which lasted for 653 hours and 34 minutes (27 days), the Key brothers held the world record for sustained flight. The *Ole Miss* is on display in the Smithsonian National Air and Space Museum. In 1965, Algene "Al" Key defeated incumbent Meridian mayor Henry Burns, and Key served as mayor of Meridian from 1965 until 1973.

When World War II erupted in Europe, Lauderdale County's young men went to war; some would never return. The Doughboy Monument, located in the triangle downtown, honors Meridian's veterans of foreign wars. Lauderdale County, long established in the military, is home to the Mississippi National Guard at Key Field and Naval Air Station (NAS) Meridian.

Before becoming Meridian's first Jewish mayor, Al Rosenbaum was instrumental in bringing the NAS Meridian to Lauderdale County. Construction on the Naval Air Station began in 1957 and created new jobs and growth in Lauderdale County.

In the 1960s, racial tensions flared across the state. In Meridian, the educational building of the Jewish synagogue, Temple Beth Israel, was bombed. Churches were burned across the state, and three civil rights workers—Michael Schwerner, Andrew Goodman, and James Chaney—were

slain somewhere between Meridian and Philadelphia, Mississippi. The ensuing trial cast Meridian into worldwide news.

In the 1970s, the downtown shopping district declined as its buildings were abandoned for retail space in more modern shopping centers. The city struggled with the unoccupied buildings, but the 1980s brought a new awareness of the worth of Meridian's historic buildings. Today, new growth of retail space below condominiums, the restoration of the Grand Opera House under the direction of the Mississippi State University (MSU) Riley Center, and the restored Marks Rothenberg Building on Fifth Street have ushered in a new era of preservation. The 16-story Threefoot building erected during the Great Depression has fallen into disrepair, and its future is not yet known.

Congressman G.V. "Sonny" Montgomery, a Meridian native, served in the US House of Representatives from 1967 to 1997. He was a staunch supporter of Meridian and its military and Naval Air Station. During his years of service, Montgomery maintained an office in the federal building in Meridian.

The arts have drawn people to Meridian since the opening of the Grand Opera House in 1890. Today, the Jimmie Rodgers Museum and the Mississippi State University Riley Center draw people from all over the nation.

The future of Meridian lies in the hands of its people, who can ensure the growth of the city and county in which they live.

One

THE EARLY YEARS

Throughout the passage of time, man has recorded history, and Meridian, steeped in rich heritage, recorded much of its own. The settlement once known as Sowashee became the largest city in Mississippi by the early 1900s.

Through the vision of three men—Richard McLemore, Lewis Ragsdale, and John T. Ball—the village was reborn after the Civil War, after Gen. William Tecumseh Sherman's torch burned the village and few buildings survived. Meridian rose from its ashes, a new city emerging in Sherman's wake.

The railroad and rich resources of virgin pine led to manufacturing, cotton mills, lumber mills, wholesalers, and retailers. A sewage system ran throughout the city, and a hook and ladder fire department placed cisterns of water for use during the many fires that plagued Meridian in its early years.

The city and county withstood the yellow fever epidemic and its economic impact in 1878, the drop in cotton prices, and the devastation of the 1906 tornado. Through it all, Meridian continued to grow as it entered the golden age in 1890. It was said during this period that one would not recognize Meridian from one year to the next as new buildings went up and businesses boomed.

In the following years, buildings made of brick and rich in architectural detail, some several stories high, dotted the downtown landscape as businesses prospered.

Meridian is indebted to its small Jewish population, including Israel Marks; Sam, Levi and Marks Rothenberg; Joseph Baum; and the Threefoot brothers (H. Marshall, Kutcher, and Lewis) for their successful businesses that influenced the city's growth.

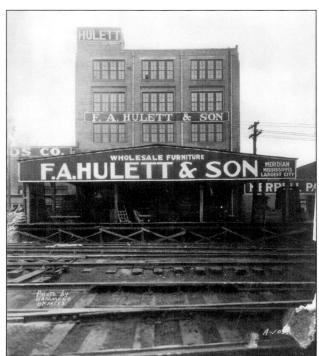

The sign on the F.A. Hulett & Son Wholesale Furniture loading dock, located at 2227 Front Street, boasts of Meridian as the largest city in Mississippi. F.A. Hulett, established in 1885, served Meridian for 125 years before closing its doors in 2010. (Courtesy of the *Meridian Star*.)

George Elkin was a grain merchant in 1900. This photograph depicts the storefront of the Elkin Henson Grain Company. (Courtesy of the *Meridian Star*.)

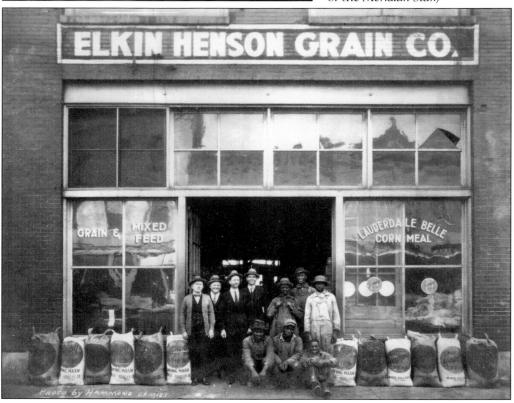

The Victorian-style Grand Opera House opened on December 17, 1890, during the height of Meridian's golden age. The owners were half-brothers Israel Marks and Levi Rothenberg. They hired architect G.M. Torgenson to design the Marks Rothenberg Building and adjoining opera house. The theater closed in 1927, and its doors remained closed for the next 70 years. (Courtesy of the *Meridian Star*.)

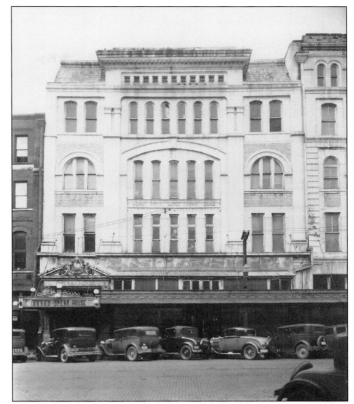

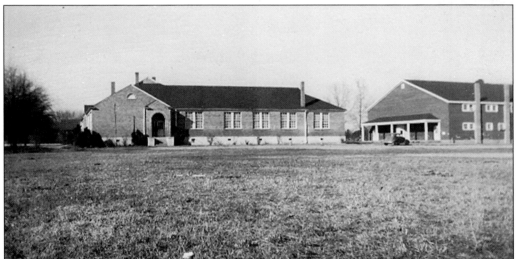

The early-1900s redbrick Vimville School is seen on the left, and the gymnasium is on the right. The gymnasium's wood structure was referred to as the Cow Palace by students after it became a private school known as Jeff Davis Academy. The academy closed around 1989 and became Southeast Middle School. The school, located on Jeff Davis School Road, was closed when it was partially destroyed by a tornado in 1992. It has since been replaced by a new Southeast Middle School. (Courtesy of Mattie Lou Downey.)

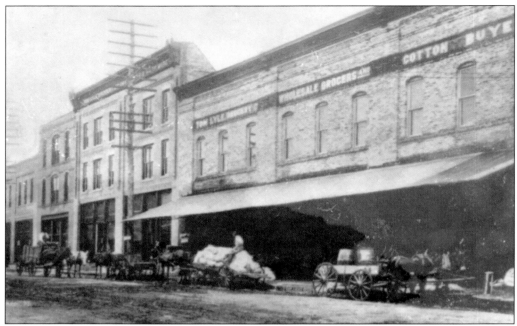

Tom Lyle Wholesale Grocers and Cotton Buyers, located on the corner of Fourth Street and Twenty-first Avenue, was destroyed during the 1906 tornado. John Thomas Lyle's home was located at 916 Twentieth Avenue. His son, John Thomas Lyle Jr., was 35 years old when he registered for the draft in 1918, listing his occupation as wholesale grocer. (Courtesy of the *Meridian Star*.)

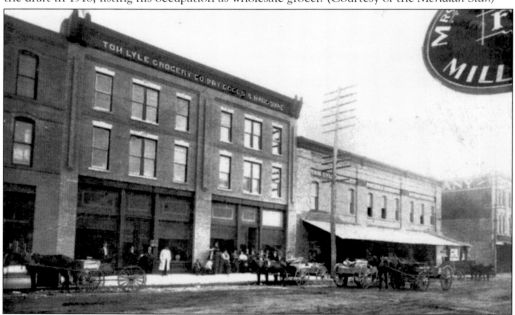

Tom Lyle Wholesale Grocers and Cotton Buyers was one of Meridian's largest wholesale companies. The four-story building that housed the grocery was destroyed in the tornado that swept through the area on March 2, 1906. After the 1906 tornado destroyed his establishment, Lyle became proprietor of Tom Lyle Grocery Co. Dry Goods & Hardware. (Courtesy of the *Meridian Star*.)

Ethel Leah Darby of Missouri poses in front of the Frank Zehler monument at the intersection of Fourth Street and Twenty-third Avenue about 1910. The monument honors Frank Zehler, a Meridian firefighter who died in the early 1900s from injuries sustained while on duty. This early street scene shows banners advertising the Mississippi Fair. The monument was relocated to Highland Park when automobiles became the primary mode of transportation. (Courtesy of William L. White.)

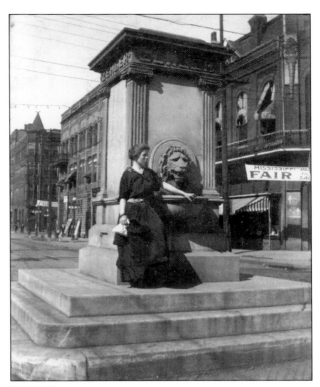

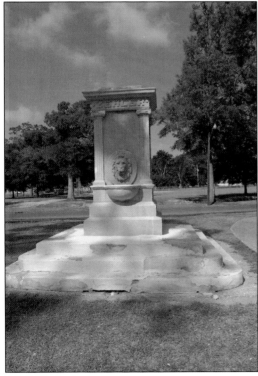

The Frank Zehler monument, once located downtown, is shown in its current spot in Highland Park. Zehler, Meridian's first fire chief, fell from a hook-and-ladder fire wagon and never recovered from his injuries. He died one year later. (Courtesy of June Davis Davidson.)

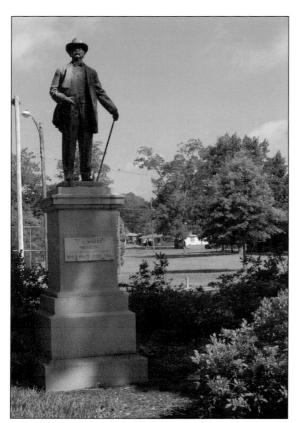

This is the Levi Marks statue at Highland Park. Marks donated much of the land for the 32-acre park once serviced by Meridian Light and Railway streetcars. The park was founded in 1895. (Courtesy of June Davis Davidson.)

This photograph shows the interior of the Lide and Cheatham Drugstore, which was located in downtown Meridian during an era when it was common for drugstores to have soda fountains and tables. Most served sandwiches, milk shakes, banana splits, sundaes, and soda. (Courtesy of Sheila Hutcherson.)

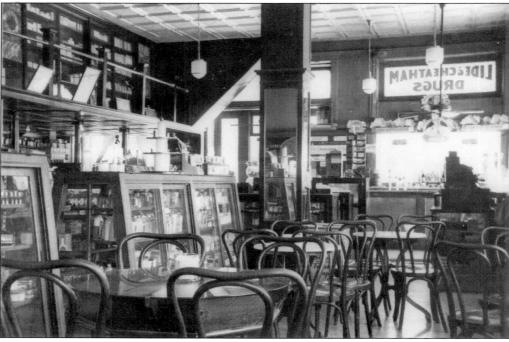

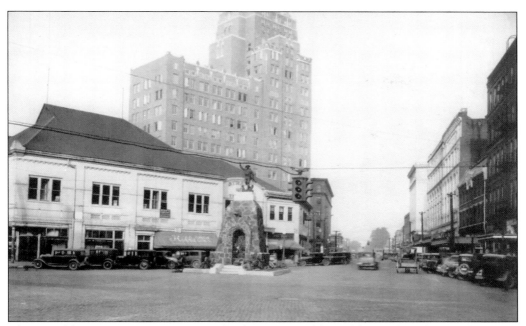

The Doughboy Monument on Twenty-third Avenue and bound by Sixth and Seventh Streets was dedicated on November 11, 1927, by the American Legion's T.D. Carter post. The sculpture was created to honor those who served in World War I. (Courtesy of the *Meridian Star*.)

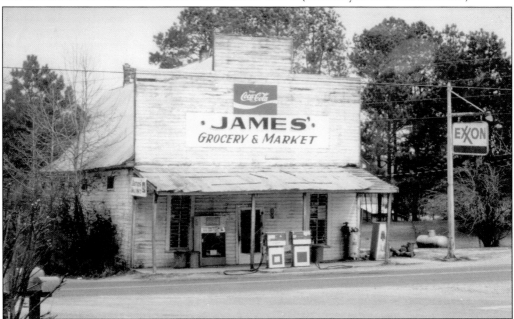

James Irby's grocery store (established around 1885) was once located on the corner of Causeyville-Vimville Road and Causeyville Road, 11 miles south of Meridian. A long counter was to the right of the entrance to the one-room store, and the walls and floors were made of heart pine. In prior years, the store was under the ownership of the Blanks and the Ford families. (Courtesy of Doris Irby.)

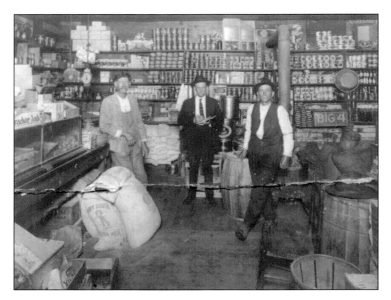

General merchandise stores, such as the one shown here, were common from the 1800s to the 1940s. Orders were placed with the clerk, who would then fill the order from the store shelves. General merchandise stores served community farmers and their families. (Courtesy of Pam Waggoner.)

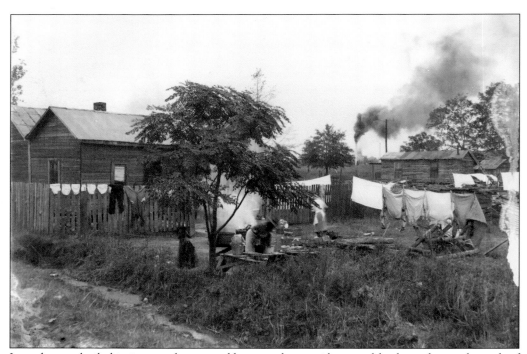

Laundry was boiled in iron wash pots and hung to dry outside, a weekly chore that took much of the day to complete. Clothes were sprinkled with water and then pressed with a flatiron heated in the hot ashes of a fireplace. Suet was wiped away with a clean cloth each time a flatiron was removed from the hot ashes. (Courtesy of the *Meridian Star.*)

This photograph depicts the Meridian Baking Company. (Courtesy of the Lauderdale County Department of Archives and History.)

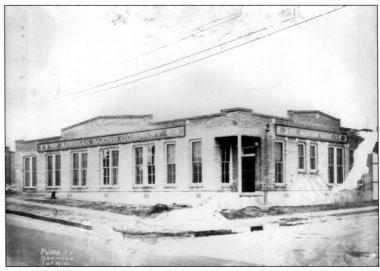

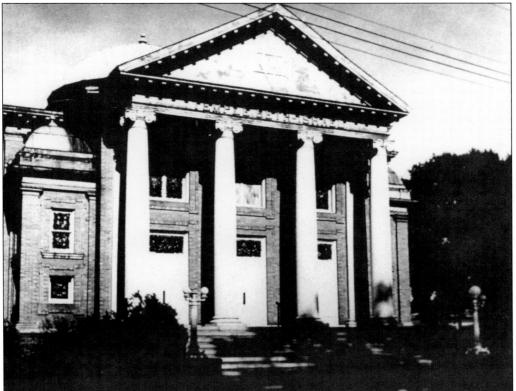

On May 28, 1968, the educational building of Temple Beth Israel was bombed by members of the Ku Klux Clan, Thomas Tarrants, and Danny Joe Hawkins. Tarrants served eight years in Parchman Prison for his part in the bombing and attempted bombing of the Meyer Davidson residence. Tarrants has brought about major changes to his life since his conversion to Christianity. Temple Beth Israel was located in downtown Meridian. (Courtesy of Goldring/Woldenberg Institute of Southern Jewish Life.)

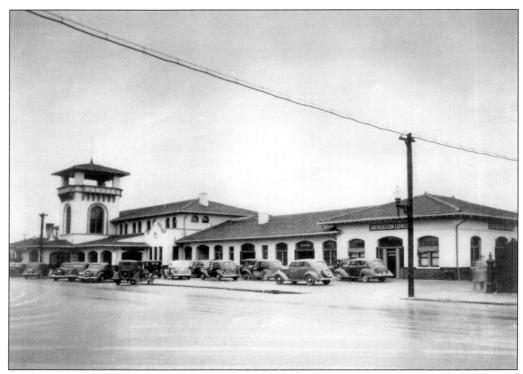

This photograph shows Union Station at 1901 Front Street in the 1930s. The railroad played an important role in Meridian's prosperity from the late 1800s to the mid-1900s, with over 44 trains arriving daily on its five rail lines. The Meridian Railroad Museum, at 1805 Front Street, is adjacent to Union Station. (Courtesy of Russell Keen.)

This image shows city streets in Meridian during an era when residential areas were unpaved. Travel over clay roads was difficult during wet weather and often caused deep-rutted roads. (Courtesy of the *Meridian Star.*)

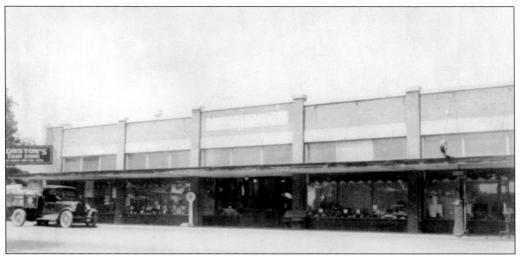

Penny scales (visible near the center of the photograph, under the awning) were common until the mid-1950s. This photograph features Houston's Cash Store. (Courtesy of the *Meridian Star*.)

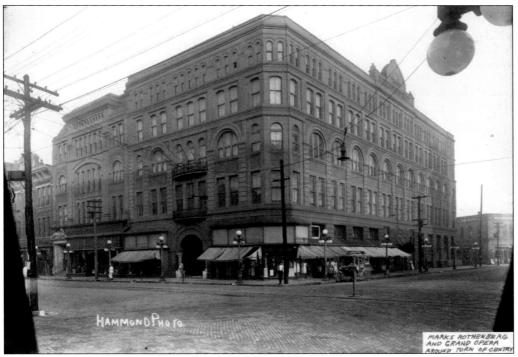

Meridian's main streets in downtown were paved with brick in 1900. Shown is the Marks Rothenberg Building at the intersection of Twenty-second Avenue and Fifth Street. The Marks Rothenberg Building was erected in 1889 by half-brothers Israel Marks and Levi Rothenberg, who saw the potential of a growing city. The brothers also built the adjoining Grand Opera House. The opera house closed in 1927 but was later renovated and reopened as the Mississippi State University Riley Center in September 2006. (Courtesy of Russell Keene.)

Pictured in this photograph is Ethel Beeson holding an unidentified child. She is the daughter of George Beeson, the founder of Meridian's Beeson College. (Courtesy of the Lauderdale County Department of Archives and History.)

This photograph shows Sinclair Floral Company, a prospering business in Meridian, in the mid to late 1920s. (Courtesy of the *Meridian Star*.)

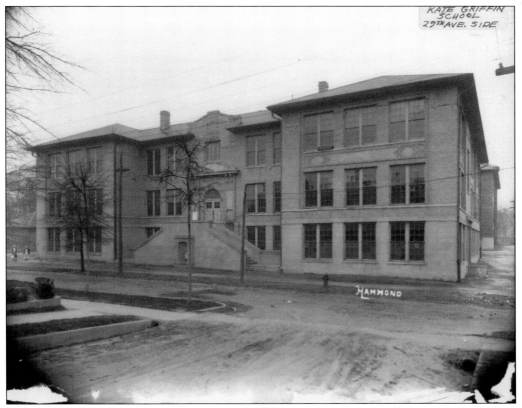

Kate Griffin School was located on the corner of Twenty-ninth Avenue. This photograph is from the early 1900s. (Courtesy of Russell Keen.)

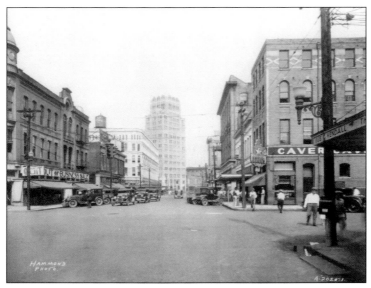

In this street scene from Meridian during the early 1900s, the Gus G. Kendall Drugstore is shown at right, on the corner of Twenty-second Avenue and Fourth Street. Meridian was home to several drugstores in the 1920s. Downtown businesses flourished until the Great Depression. Recovery slowed when retailers moved to the new shopping centers and malls in the 1970s. (Courtesy of the *Meridian Star*.)

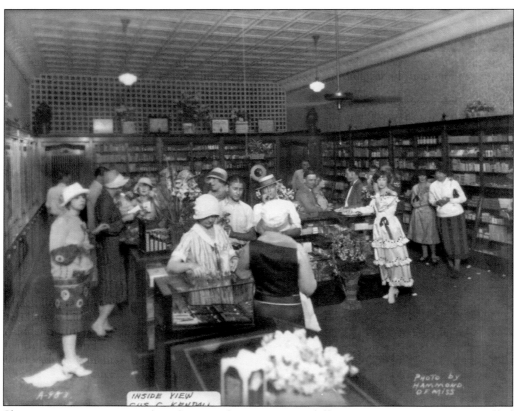

Shoppers enjoy a variety of products in the Gus G. Kendall Drugstore. Druggists, now called pharmacists, often advertised in Meridian's early business directories. Gus G. Kendall Drugstore was located at 400 Twenty-second Avenue on the northeast corner of Twenty-second Avenue and Fourth Street. (Courtesy of Russell Keene.)

Meridian thrived until the 1970s, when some retail merchants moved from downtown to shopping centers located at College Park, Broadmoor, or the Village Fair Mall. Small shops are returning to the downtown area. (Courtesy of the *Meridian Star*.)

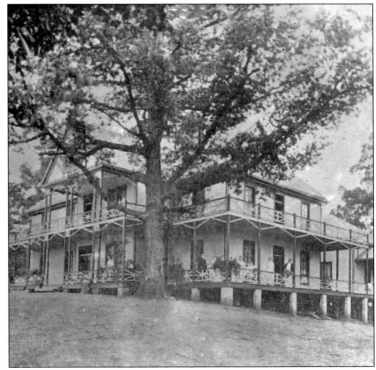

A hack line ran from Meridian to Lithia Arundel Springs Health Resort and Hotel. Advertisements promoted springwater full of minerals that could cure various ills. (Courtesy of the Lauderdale County Department of Archives and History.)

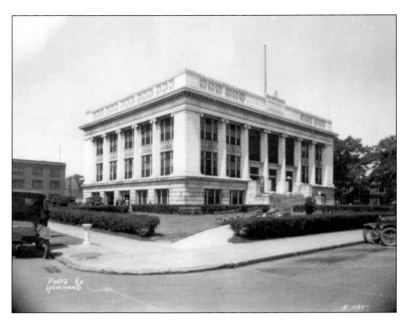

City Hall was designed by Gustav Torgenson, the same architect who designed the Marks Rothenberg Building (now the MSU Riley Center). The current city hall, built in the Beaux Arts style in 1915, replaced the 1885 city hall during Meridian's golden age. City Hall is located at 601 Twenty-fourth Avenue. (Courtesy of Russell Keen.)

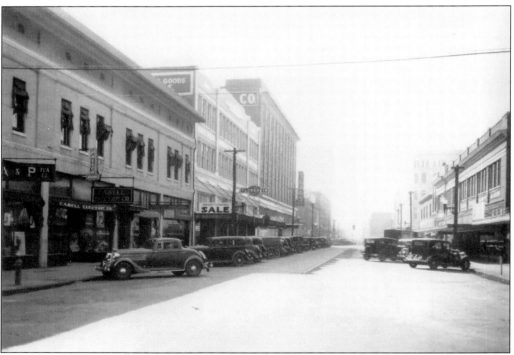

This image shows a busy street scene on the east end of Fifth Street at a time when most cars were painted black and hand cranked. Hand cranks were eventually replaced with a starter button on the left side of the floorboard, near the clutch. The Alex Lobe Building is on the left in the foreground, and Sears is at the corner of Twenty-second Avenue and Fifth Street. Front Street, Twenty-second Avenue, and Fifth and Sixth Streets were among the busiest in town. (Courtesy of Russell Keen.)

A scenic drive
on Highway 45
South overlooks
Meridian. (Courtesy
of Russell Keen.)

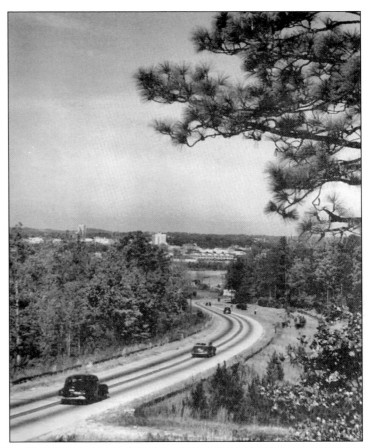

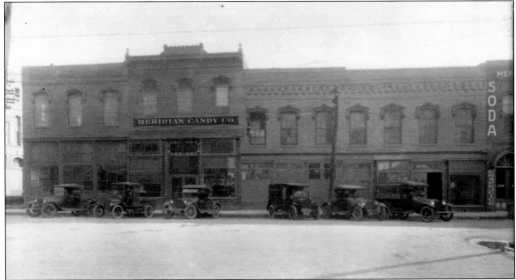

Meridian Candy Company was one of the many thriving businesses in Meridian during the early 1900s. (Curtsey of the Lauderdale County Department of Archives and History.)

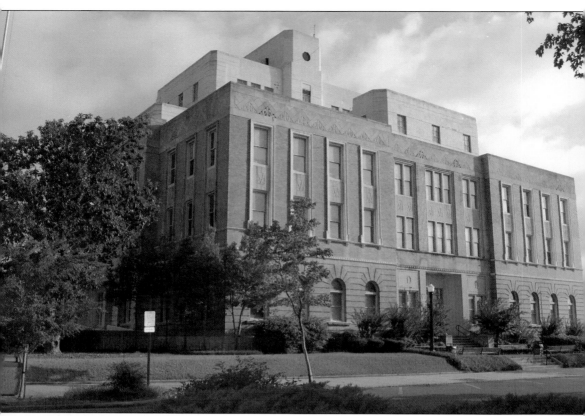

The Lauderdale County Court House is located on the corner of Twenty-first Avenue and Fifth Street. At one time, the county jail was located in the courthouse. After the new jail was erected, it was moved to a location on Fifth Street near the former Lamar Hotel, now the courthouse annex. (Courtesy of June Davis Davidson.)

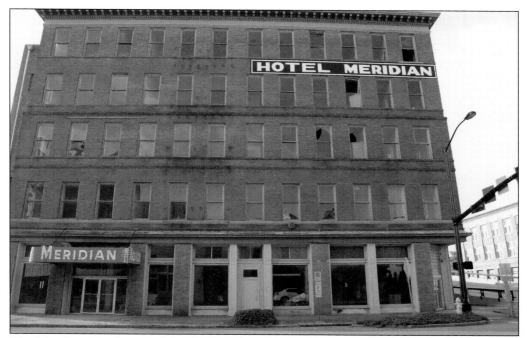

The Meridian Hotel is scheduled for demolition in the fall of 2011. The hotel is located on the southeast corner of Twenty-second Avenue and Fifth Street. The hotel was built in 1907 by Louis H. Arky. (Courtesy of June Davis Davidson.)

This is a west side view of the Meridian Hotel that faces Twenty-second Avenue. (Courtesy of Richelle Putnam.)

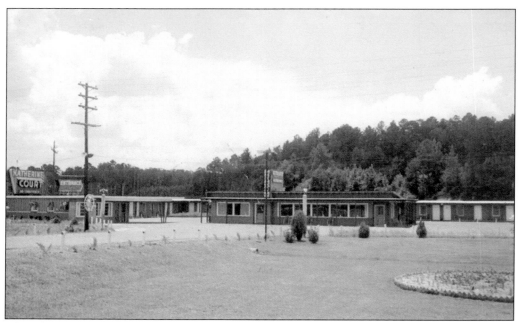

This photograph shows the Katherine Court Motel and Restaurant on South Frontage Road. (Courtesy of the Lauderdale County Department of Archives and History.)

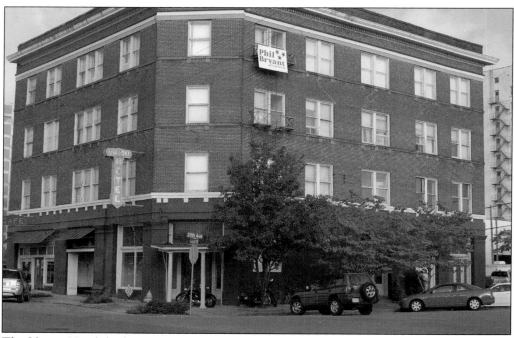

The Union Hotel, built in 1908, is one of Meridian's oldest hotels. The owner at the time of construction was P.C. Steele. The hotel ownership changed numerous times over the course of its history until its closure on December 18, 1973. The Union Hotel, located at 1805 Front Street, has been converted to apartments. (Courtesy of June Davis Davidson.)

The Raymond P. Davis Annex Building is the former Lamar Hotel built by Harold Meyer in 1927. The annex is located at 41 Twenty-first Street. (Courtesy of June Davis Davidson.)

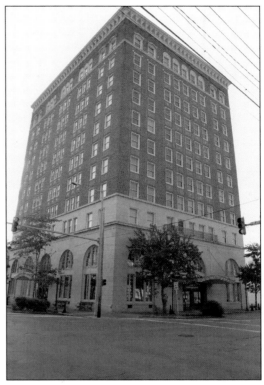

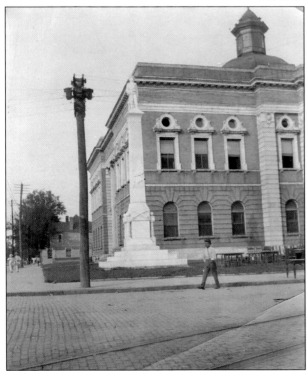

This photograph shows the old Lauderdale County Courthouse on brick-lined streets. The rails for the trolley line are also visible. The Confederate Monument shown here was removed and replaced with a wall honoring men of foreign wars at the entrance of the courthouse. (Courtesy of the *Meridian Star*.)

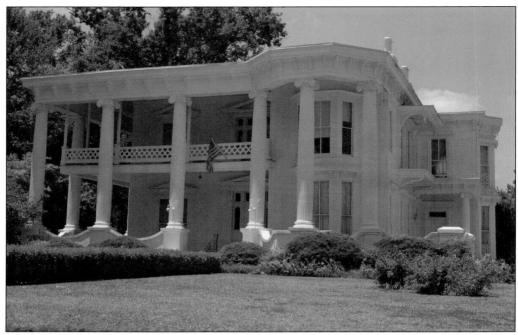

The Merrehope property, located at 905 Martin Luther King Drive, was deeded in 1859 to Juriah McLemore and her husband, W.H. Jackson, by Juriah's father, Richard McLemore. During the Civil War, the home was occupied by Gen. Joseph E. Johnson. Merrehope was one of six structures left standing after Sherman burned Meridian. (Courtesy of June Davis Davidson.)

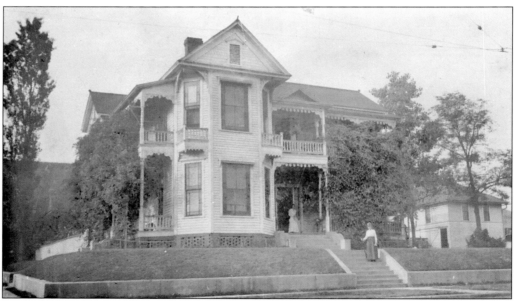

Two women are pictured outside a residential home during the late 1800s, a time when affluent businessmen built numerous large homes. Many of these homes are still in existence in Meridian; a few are located on Poplar Springs Drive. (Courtesy of the *Meridian Star*.)

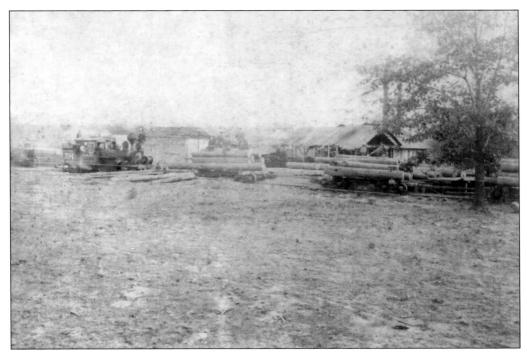

Trains hauled lumber from Mayerhoff Lumber Mill in Sageville to buyers across the country. Sageville is now known as the Arundel community that is located on Highway 11 South in Lauderdale County. (Courtesy of Mary Ruth Bordron.)

The Irwin Motel and Restaurant was located on Highway 80, east of Meridian. Local legend says the mob from northern states congregated at the secluded motel in the years before 1950. (Courtesy of Dave Kimbrell.)

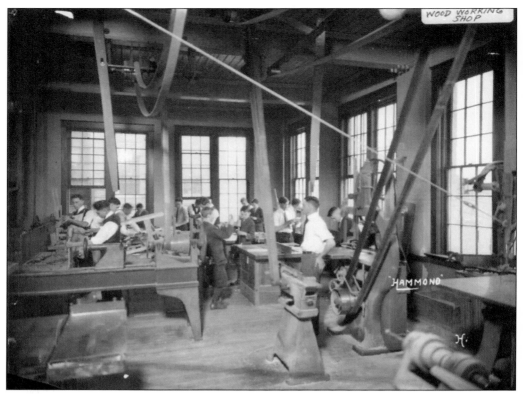

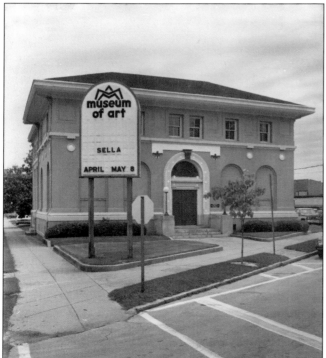

This photograph shows the woodworking shop at Kate Griffin School in the early 1900s. (Courtesy of Russell Keen.)

The Museum of Art opened in 1970 on the corner of Seventh Street and Twenty-fifth Avenue, former site of the Carnegie Library. (Courtesy of the *Meridian Star*.)

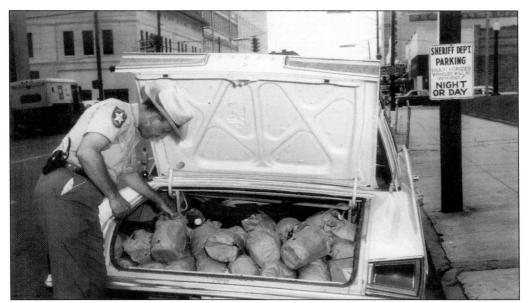

Moonshine stills in Lauderdale and surrounding counties kept law enforcement officers on the lookout for the illegal activity of selling untaxed liquor. In this image, an officer in Meridian inspects a stash of moonshine wrapped in brown paper bags, which helped prevent breakage. (Courtesy of the *Meridian Star.*)

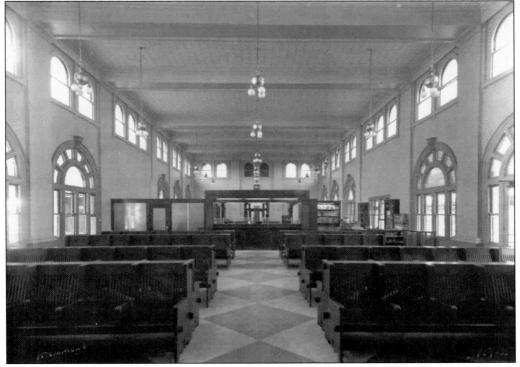

This is the spacious interior of Union Depot on Front Street during the 1940s. (Courtesy of the *Meridian Star.*)

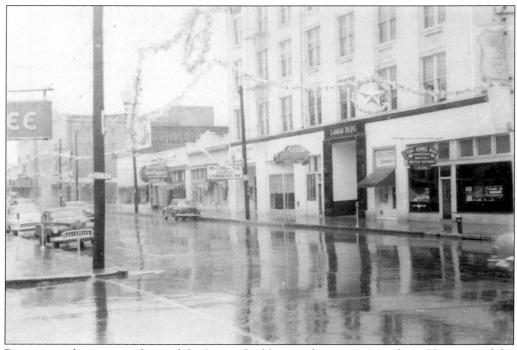

Rain swept the street in front of the Lamar Building in downtown Meridian. (Courtesy of the *Meridian Star*.)

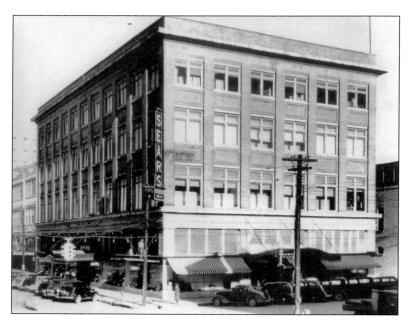

Sears was located on the southeast corner of Twenty-second Avenue and Fifth Street until it moved to its new location at 405 Twenty-second Avenue in 1964. Sears remained at this location until 1997, when it became one of the anchor stores at Bonita Lakes Mall. (Photograph courtesy of Russell Keen.)

The six-story Miazza Woods Building, also known as the Flatiron Building, survived two fires in the 1930s. The first fire destroyed the fourth and fifth floors, while the second fire destroyed the second and third floors. The remaining single-story building, on the triangular-shaped block, is located on Twenty-second Avenue, bound by Sixth and Eighth Streets. Today, the Miazza Woods Building is a single-story structure. (Courtesy of Richelle Putnam.)

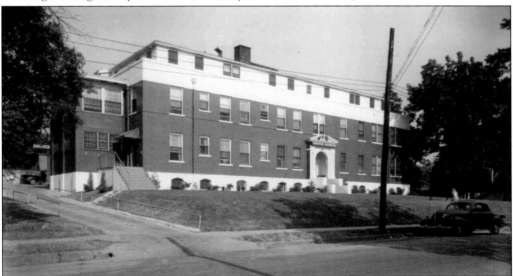

Dr. William Jefferson Anderson acquired the former 30-bed Turner Hospital on Fourteenth Street in 1929. At his passing, his son Dr. William "Billy" J. Anderson Jr. instilled the same values in health care service as his father. Today, it is a 400-bed facility with over 1,700 employees and a staff of 200 physicians. The name has changed throughout the years from Anderson's Infirmary to Jeff Anderson Memorial Hospital to Anderson's Regional Hospital. (Courtesy of the *Meridian Star*.)

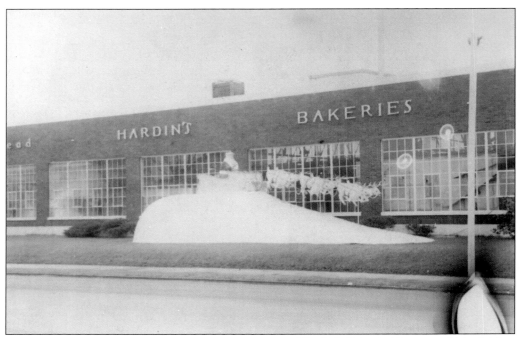

Hardin's Bakeries' Santa and his sleigh were displayed at Christmastime in front of the bakery, which was located on Twenty-second Avenue. (Courtesy of the *Meridian Star*.)

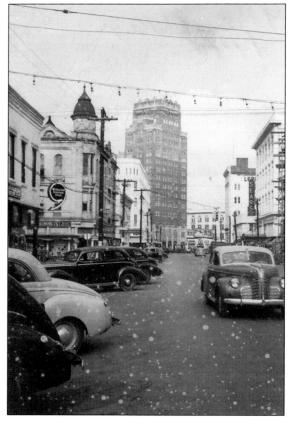

Snow was common in the winter during the 1930s. Winter came early in Mississippi, which stayed cold until early spring. Before central heat was installed in homes, people warmed themselves using an open fireplace or a wood heater. (Courtesy of the *Meridian Star*.)

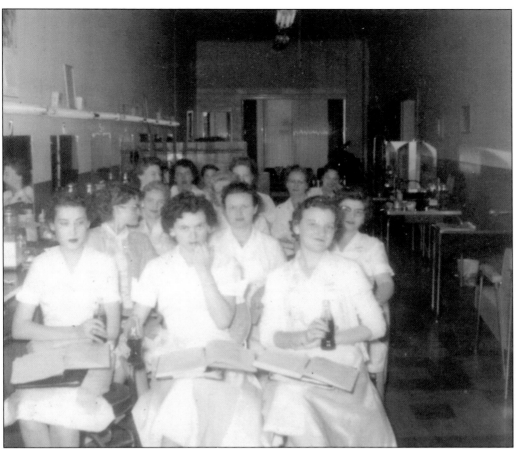

Students attend class at Townson Beauty School in 1957. The school was located on the corner of Twenty-third Avenue and Seventh Street in Meridian. (Courtesy of Dolores Ratcliff.)

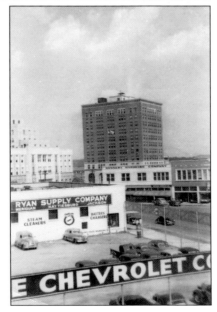

This photograph shows Ryan Supply Company and Nunnery Hardware Company in downtown Meridian. (Courtesy of Sheila Hutcherson.)

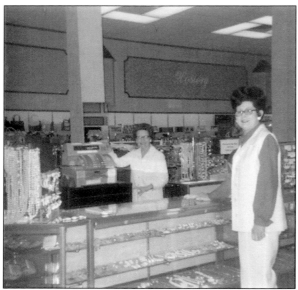

In this 1960s image, clerks pose at the Marks Rothenberg department store on Fifth Street. (Courtesy of Glenda Hughes.)

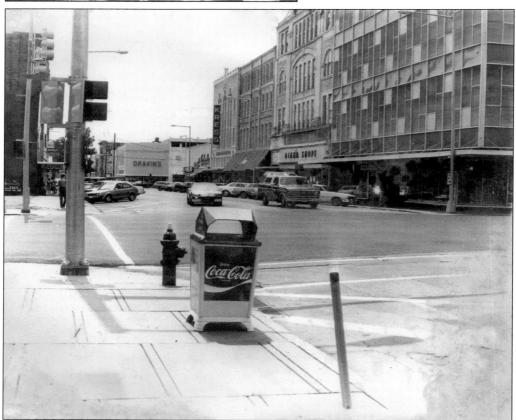

A 1960s street scene shows Marks Rothenberg, the Diana Shops, and the Kress building on Fifth Street. Dravin's department store was located on the corner of Fifth Street and Twenty-third Avenue. (Courtesy of the *Meridian Star*.)

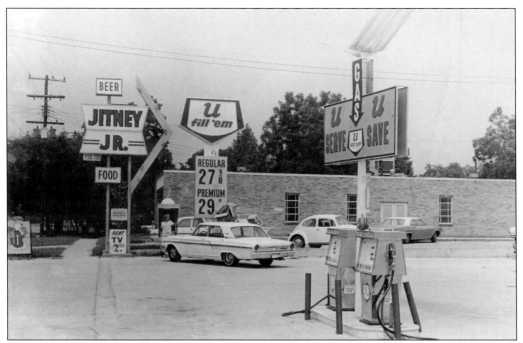

This late 1950s photograph shows a bygone era in Meridian, when gasoline sold for 27¢ per gallon. (Courtesy of the *Meridian Star.*)

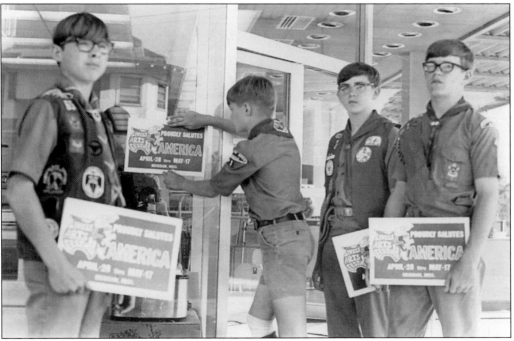

In this image, Boy Scouts place Lively Arts Festival posters on a shop window. Pictured here are, from left to right, David Medlin, Jim McInnis, Warren Culpepper, and Bruce Bishop. (Courtesy of the *Meridian Star.*)

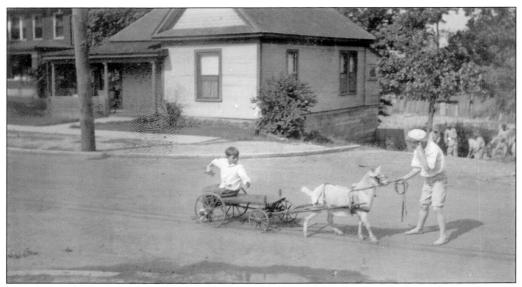

Pet goats were common on farms. Boys often played with slingshots made from clothespins and thin rubber strips cut from inner tubes. They also played "corn war" with dried corncobs at a time when yards were swept with a brush broom to prevent grass from growing. Sweeping the yard was often a Saturday chore for children. (Courtesy of the *Meridian Star*.)

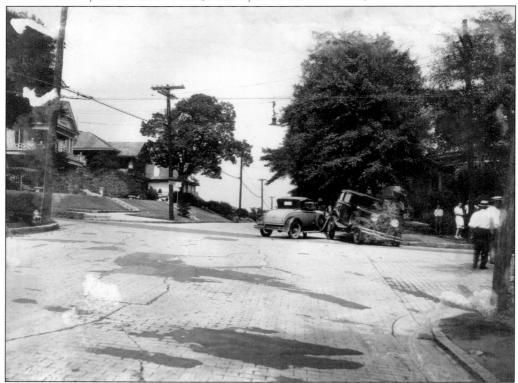

A crowd gathers at the scene of an automobile accident in a residential area of Meridian. (Courtesy of the *Meridian Star*.)

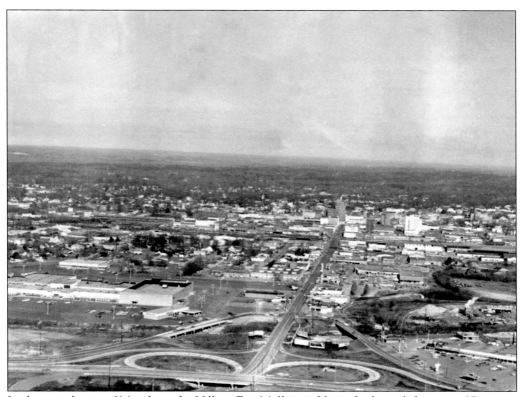

In this aerial view of Meridian, the Village Fair Mall is visible in the lower left corner. (Courtesy of the *Meridian Star.*)

Matty Hersee, a charity hospital, closed on June 30, 1989. During the intervening years, the Matty Hersee Training School for Nurses graduated its first student, Ada Boone, in 1913. The school closed in 1953 and reopened from 1956 to 1986. Matty Hersee Hospital is located on the corner of Highway 11 and 19 North. (Courtesy of June Davis Davidson.)

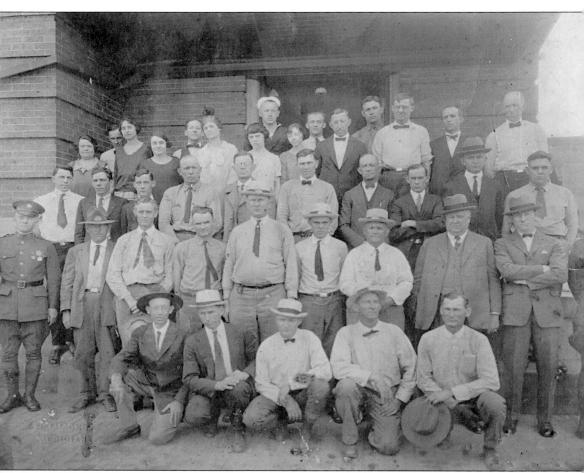

Known names of those shown are Mims Fred Simmons; Fred Whitney; George M. Bates; postmaster Charles Hyde; Lamar M. Bustin; James C. Doweny, mayor of Meridian; Roy Gamblin, assistant postmaster; Luther K. Ellis; Owen E. Burroughs; Alfred L. Young; Lawrence E. Smith; Willie Gunn; Jessie Boyd; Ruth Malone; Florrie Dement; Mrs. V.L. Mosley; Francis May Brown Hobbs; Christine Fallon; B. Clyde Winberley; Vadon L. Mosley; Robert H. Phillips; Richard Simmons; Henry S. Woodall; and postal inspector Stanley Odell Harbour. (Courtesy of the Lauderdale County Department of Archives and History.)

Two

RAILROADS AND TRANSPORTATION

At a time when word of mouth traveled faster by horseback than train tracks, John Ball could hear the approaching whistle of the steam engine before it reached Lauderdale County.

The first railroad destination for Lauderdale County was Marion Station. At the time, Marion Station was the largest town in the county, but Marion's railroad destination ended in 1855, when the competitive Ball built a depot in Meridian.

Ball registered the name Meridian with the postal service for a post office at his store. This ended the town's name conflict between John Ball and Lewis Ragsdale, who wanted the village to be named Ragsdale City.

During the Civil War, the *Mississippi Southern* left the depot in the early hours of February 19, 1863, with Confederate troops bound for the battle of Vicksburg. As the train crossed the Chunky Creek Bridge near Hickory, the engine went offtrack and plummeted into the icy cold water below. Many were saved by the First Battalion of Choctaw Indians camped nearby.

Much of the railway system in Meridian was destroyed when Gen. William Tecumseh Sherman and his troops set fire to the small village in February 1864. Sherman's action destroyed the Confederate arsenal, buildings, and railway tracks. Only six buildings escaped his torch. After the Civil War and Reconstruction, Meridian began to rebuild its rails, and after 26 working days, repairs were completed.

The railroads played an important role in Meridian's growth. Timber and cotton were shipped by rail at a time when 44 trains came in and out of Meridian daily on its five tracks. Tourists, whose destination was one of the mineral springs and resorts in Lauderdale County, arrived by train.

Streets, once paved with wood blocks, were laid with bricks, and a trolley line soon ran throughout the city, colleges, and Highland Park on over 13 miles of rail. This era ended in 1926, when modern transportation arrived. The rails were removed when Meridian opted for buses in 1926.

John T. Ball, a merchant from Kemper County, was one of Meridian's early pioneers and was instrumental in the growth of the town. The inceptions of both the railroad depot and the post office are credited to Ball. (Courtesy of the Lauderdale County Department of Archives and History.)

Workers take a break from laying railroad tracks in Lauderdale County. Over 44 trains arrived in Meridian daily during the late 1800s and early 1920s. (Courtesy of the Lauderdale County Department of Archives and History.)

Standing on the platform of the Toomsuba Depot around 1911 are, from left to right, Herman Blanks, Mr. Phillips, and Mr. Neville. (Courtesy of Emma Lou Price.)

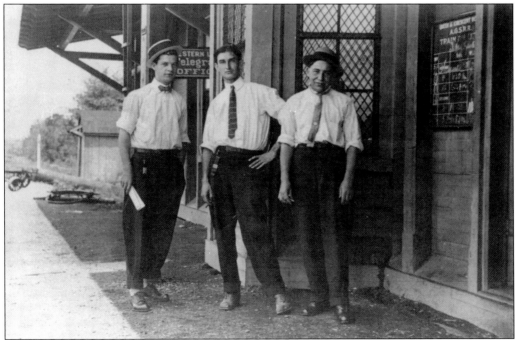

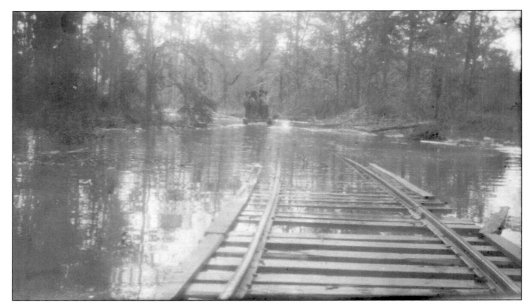

The image shows water-covered train tracks during one of many spring floods. Several creeks flow beneath Meridian, with one reportedly underneath the Threefoot building. Gallagher Creek is on the south end of Fourth Street in downtown Meridian. (Courtesy of the Lauderdale County Department of Archives and History.)

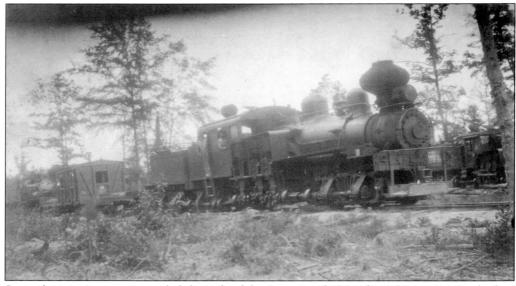

Steam locomotives once traveled the rails of the Deep South. Meridian's Union Station had up to 44 trains coming in each day over five tracks. A railroad museum is currently located next door to the depot on Front Street. (Courtesy of the Lauderdale County Department of Archives and History.)

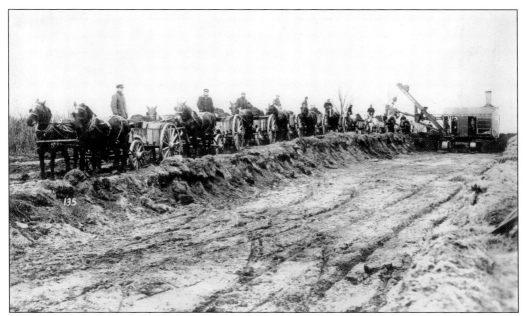

Steam shovels load soil into horse-drawn carts during early road building in Lauderdale County. (Courtesy of Dorothy Hagwood.)

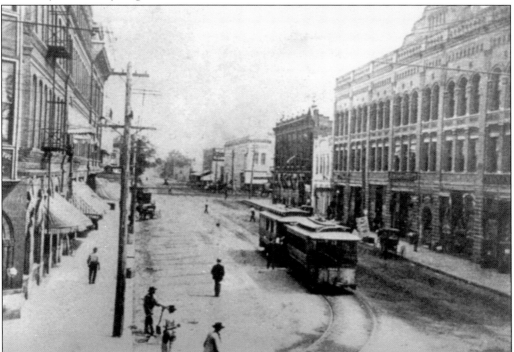

Trolley cars were a mode of transportation in Meridian during the late 1800s and early 1900s, with over 13 miles of tracks and 35 trolley cars running throughout the area. The Meridian Street Railway and Power Company later transferred to the rail system of the Meridian Light and Railway Company, and buses eventually replaced the trolley cars. (Courtesy of Charles Frazier.)

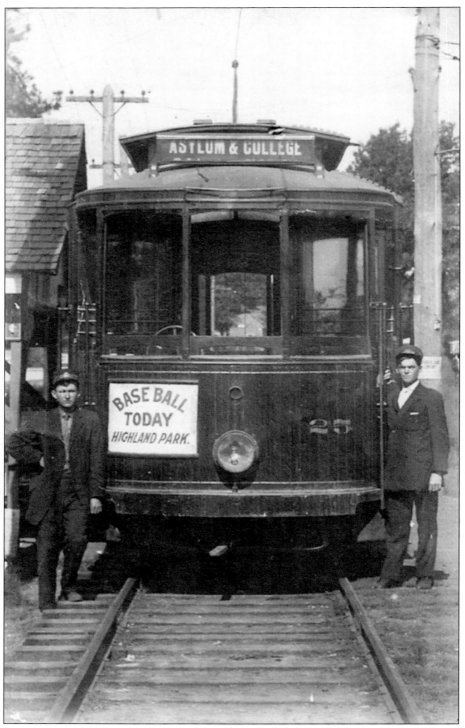

The front of the Meridian Light and Railway trolley car advertised baseball at Highland Park. (Courtesy of Russell Keen.)

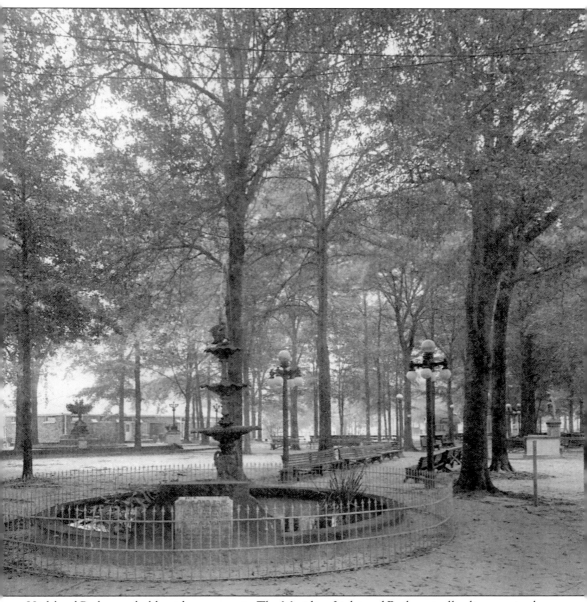

Highland Park once held outdoor concerts. The Meridian Light and Railway trolley line serviced the park until 1922, when the railway removed the tracks from its college line. Meridian passed a referendum in 1925 that ended streetcar service. (Courtesy of Russell Keen.)

Meridian transported troops and ammunition from the Confederate arsenal during the Civil War. Gen. William Sherman destroyed much of the railway in Lauderdale County. (Courtesy of the Lauderdale County Department of Archives and History.)

Three

TIMBER AND
MANUFACTURING

With timber and cotton manufacturing and rail transportation, Meridian became the largest city in Mississippi from 1890 through 1930. In the county's early history, men and teams of oxen logged in the abundant virgin pine forest of Lauderdale County. In the 1870s, companies like Long Bell Timber built railroad spurs through the county. Steam products—a portable source of power—were manufactured at Soulé Steam Feed works, which served the lumber industry from 1892 until the mid-1950s.

Long Bell Company from Quitman ran a railway spur into the southeastern portion of Lauderdale County that connected with the main line, the Meridian & Bigbee Railroad. By 1933, logging had slowed and the rail spurs were removed. Traces of the old dummy lines can be found across the county. Other small, privately owned sawmills located in Lauderdale County continued to operate. The numerous lumber mills during this period enhanced the growth of Meridian, providing thousands of boards of lumber for its buildings and shipment by rail.

Manufacturing, cotton compresses, cottonseed oil, and sawmills located in Meridian were dependent upon the city and county for its labor. Textile mills—such as Meridian Manufacturing, Alden Mills, Maywebb, and others—drew from the city and county workforce. By the 1980s, Meridian's mills closed their doors.

Logging continues in Lauderdale County. Ralph Morgan and Bill Mayerhoff have been loggers in the county for the past few decades. As timber is harvested, sapling pines are planted.

Today, other entrepreneurs have opened successful manufacturing businesses. Hartley Peavey of Peavey Electronics manufactures music and sound equipment. The name Peavey is known worldwide in the music industry.

With two major interstates, a railway, and an airport, other success stories are sure to follow.

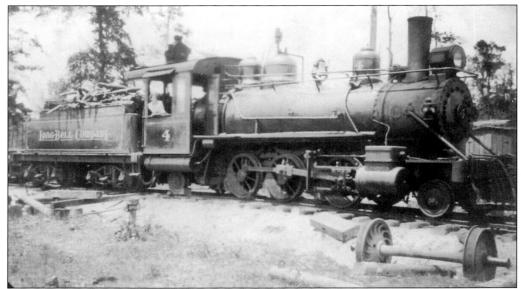

Long Bell Company built railroad spurs, often referred to as "dummy lines," into the virgin pine forest in Lauderdale County. (Courtesy of the Lauderdale County Department of Archives and History.)

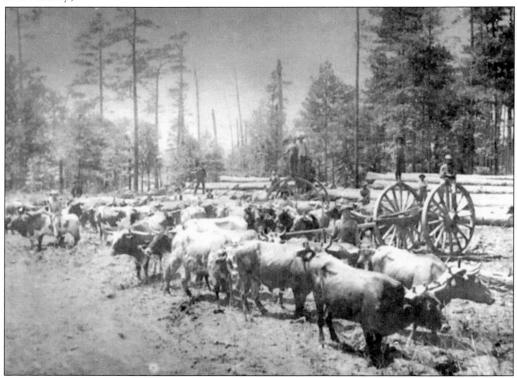

The timber industry in Lauderdale County played an important role in the growth of Meridian. These men are logging in Lauderdale County in the early 1900s. (Courtesy of the Lauderdale County Department of Archives and History.)

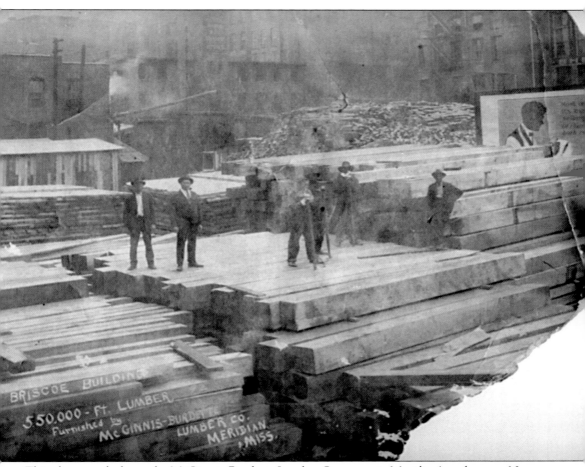

This photograph shows the McGinnis-Burdette Lumber Company in Meridian's early years. Now known only as McGinnis Lumber Company, it has been in business for 90 years. (Courtesy of McGinnis Lumber Company.)

Workers take a dinner break at the Pricilla Knitting Mill. This mill was reportedly located in the Tuxedo area. (Courtesy of Dr. Annie Sagen; photograph by Arthur Rothstein.)

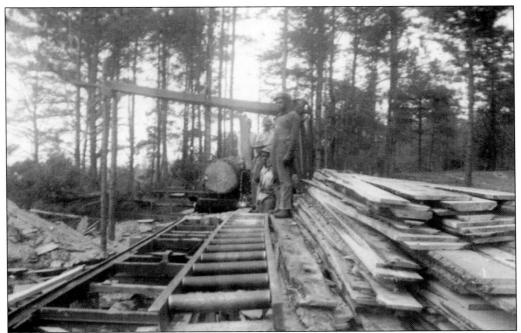

This photograph shows a Lauderdale County sawmill operation in the late 1800s or early 1900s. Lumber was transported to Meridian by rail or oxen. (Courtesy of Emma Lou Price.)

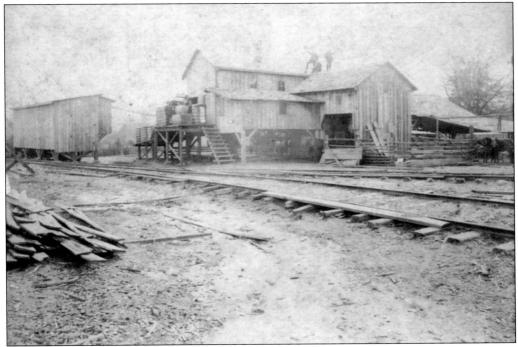

Mayerhoff Lumber Mill was one of many mills scattered across Lauderdale County in the late 1800s and early 1900s. Rail spurs ran to the larger mills to transport finished lumber to buyers. After the timber industry declined, the spurs were removed. (Courtesy of Mary Ruth Bordron.)

Unidentified workers are seen at Mayerhoff lumber mill on the Arundel Road in Sageville. (Courtesy of Mary Ruth Bordron.)

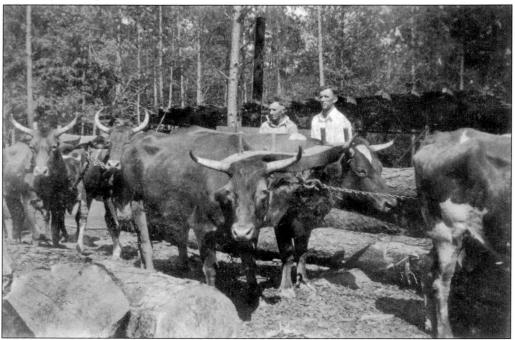

Dan Pickard (left) is shown with Preston Irby. The men used oxen to harvest timber in Lauderdale County in the early 1900s. (Courtesy of Doris Welker.)

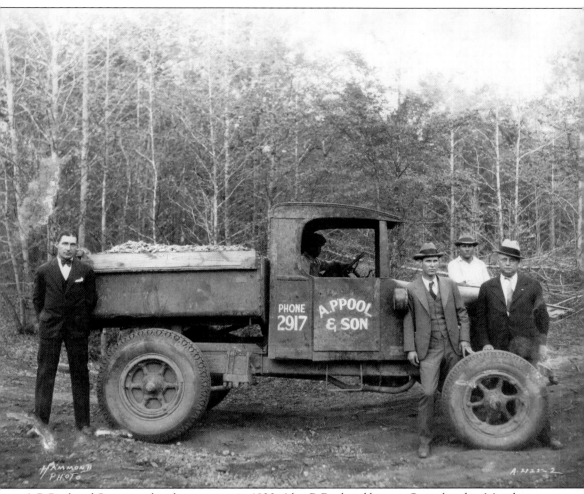

A.P. Pool and Son was a local contractor in 1920. Alva P. Pool and his son Oscar lived in Meridian in close proximity to Charles M. Wright, who was an attorney for the railroad. (Courtesy of the *Meridian Star*.)

McGinnis Lumber Company employees Larry Flood (left) and Philip Busbee pose for a photograph. (Courtesy of Jim McGinnis.)

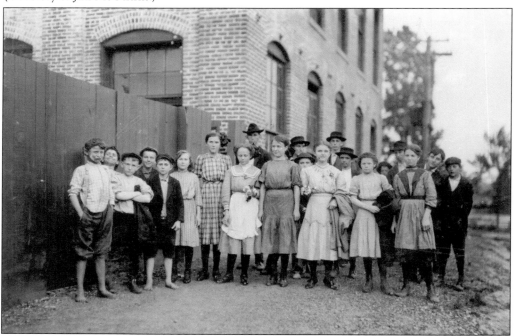

This early-1900s photograph depicts workers at Pricilla Knitting Mill. Two of the young workers are listed on the 1920 federal census. (Courtesy of Dr. Annie Sagen; photograph by Arthur Rothstein.)

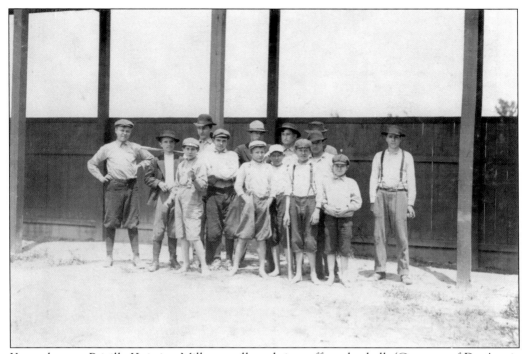

Young boys at Pricilla Knitting Mill were allowed time off to play ball. (Courtesy of Dr. Annie Sagen; photograph by Arthur Rothstein.)

Farm families often raised cane for making syrup. This syrup mill belonged to Robert Clay, who lived on Skipper Road in Lauderdale County. (Courtesy of Harlan Davis.)

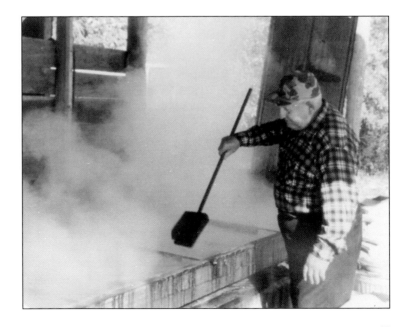

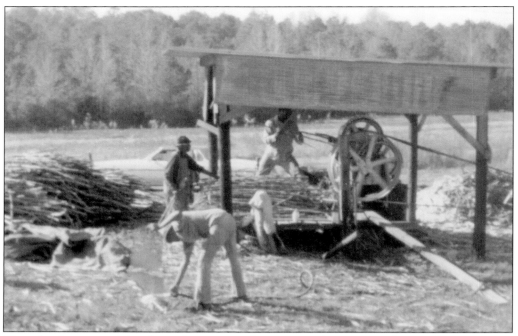

The wheel squeezes juice from the cane, and juice runs down a trough into the syrup pan. (Courtesy of Harlan Davis.)

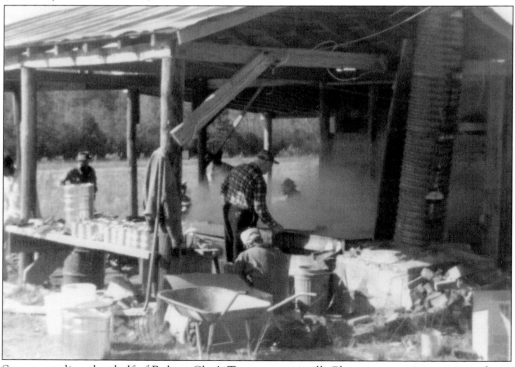

Syrup cans line the shelf of Robert Clay's Topton syrup mill. Clay stirs cane juice as it cooks in the pan until it turns into syrup. (Courtesy of Harland Davis.)

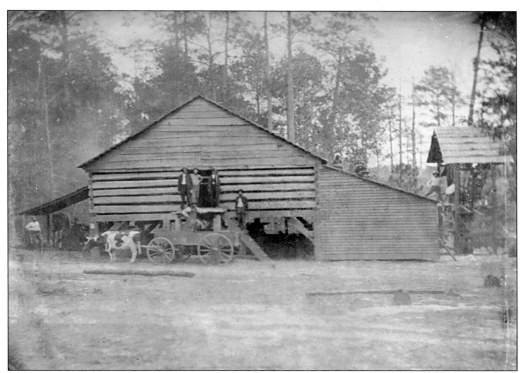

This photograph shows a mule-powered cotton gin near Causeyville in the late 1800s. (Courtesy of Dorothy Hagwood.)

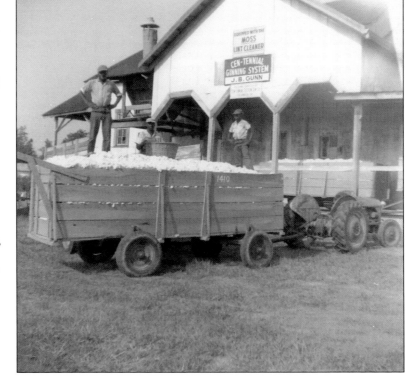

Pictured here are Robert Green (left), Horace McClellan (center), and Willie "Gab" Fortner on a wagonload of cotton at J.B. Gunn's cotton gin in Topton. (Courtesy of Harlan Davis.)

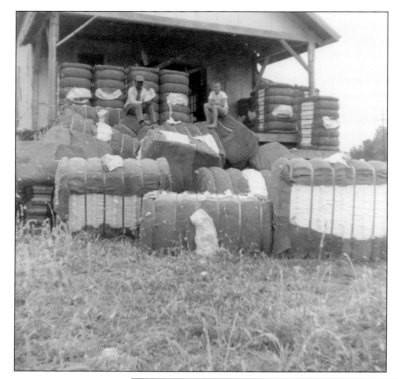

In this 1959 image, Kenneth Davis (right) and Buddy Jackson look over bales of cotton at Gunn's cotton gin in Topton, located at the crossing of Highways 45 and 493. The gin operated from 1937 through the fall of 1972. F.D. Sollie was the cotton mill ginner. (Courtesy of Harland Davis.)

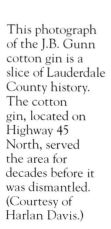

This photograph of the J.B. Gunn cotton gin is a slice of Lauderdale County history. The cotton gin, located on Highway 45 North, served the area for decades before it was dismantled. (Courtesy of Harlan Davis.)

Four

PARADES AND ENTERTAINMENT

With Meridian's rapid growth came entertainment venues, such as the Grand Opera House, the Hamas Temple Theater, the Strand Theatre, and the Pricilla Theater with its mechanical rooftop. The Ritz and Royal also became a part of Meridian's arts scene.

Meridian has been home to celebrities like Susan Akin (Miss America 1986) and well-known performers, singers, and professional ballplayers.

Meridian is known worldwide as the birthplace of Jimmie Rodgers, "The Father of Country Music," and a museum honoring Rodgers is located at Highland Park. Many of Nashville's greatest stars have performed on the Temple Theater stage during the Jimmie Rodgers Festival. Earl Aycock and Carl Fitzgerald were the first to visit Nashville and bring star performers to the Jimmie Rodgers Festival.

Meridian has been steeped in the arts since the opening of the Grand Opera House in 1890. The opera house, host to minstrel shows and vaudeville acts, eventually showed silent movies. In 1927, the opera house closed its doors for the next seven decades—it has now been restored to its former grandeur and is known as the Mississippi State University Riley Center.

The Meridian Little Theater, founded by Marjorie Woods Austin in 1932, held its first production at Highland Park. The Meridian Little Theater is one of Meridian's ongoing success stories.

Parades have been a part of life in Meridian since the late 1800s, when flower parades featuring flower-covered carriages and horse-drawn wagons were the theme. Today, as in yesteryear, parades continue in Meridian.

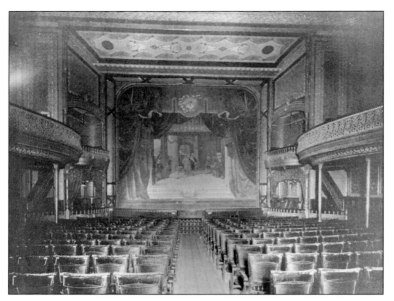

The painted lady, located in the valance of the theater curtain, overlooks the interior of the Grand Opera House in this late-1800s photograph. The opera house was leased to a subsidiary of Saenger Theatres in 1923. Unsubstantiated reports from the opera house claim paranormal activity, stating that the ghost of "the lady" appears on stage and sings. (Courtesy of the *Meridian Star*.)

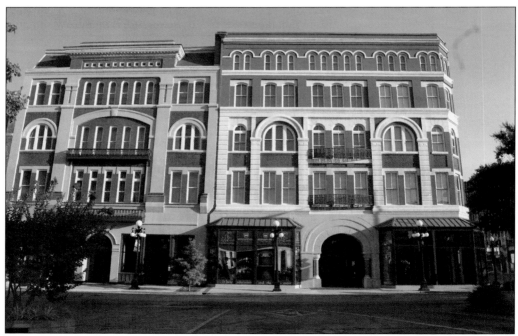

The MSU Riley Center for the performing arts is located in the former Marks Rothenberg Building on Fifth Street. The center is used for education, cultural events, and conferences. The Grand Opera House has been restored; its stage is host to well-known performing artists throughout the year. Meridian has become the arts and entertainment center of Mississippi. (Courtesy of June Davis Davidson.)

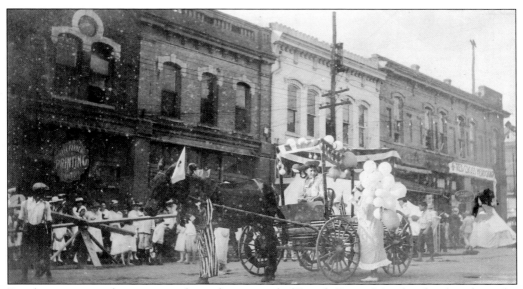

People enjoy a parade as it passes down the west end of Fourth Street. Meridian has loved parades throughout its 151-year history. Photographs of the flower parades held in the late 1800s can be found at the Mississippi State Archives. (Courtesy of the *Meridian Star*.)

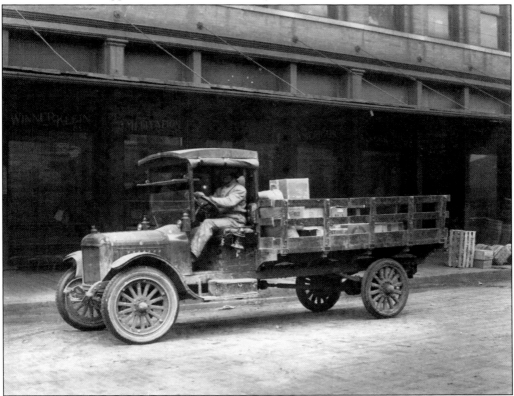

Seen here is a truck and driver in front of the Wienner and Kline Department Store on Twenty-second Avenue in downtown Meridian during the early 1900s. (Courtesy of the *Meridian Star*.)

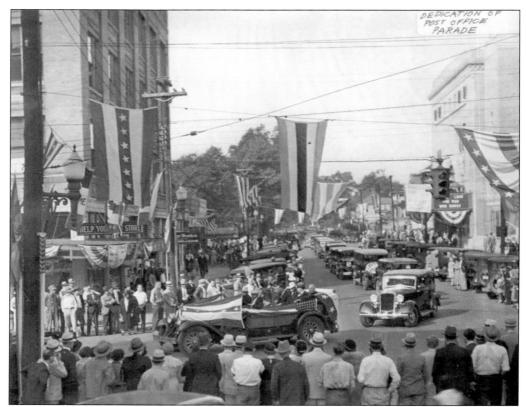

A large crowd gathers for a Fourth of July parade on Eighth Street. The Temple Theater is at right. Help Yourself Stores (visible at left) were the convenience stores of the time. (Courtesy of Russell Keen.)

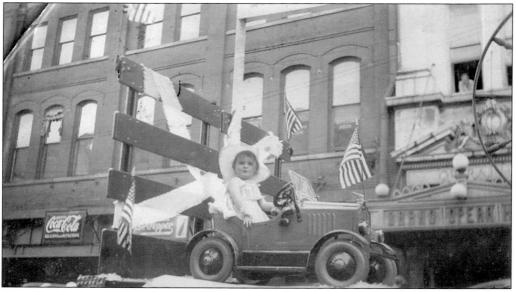

A small girl rides on a float during a parade on Fifth Street. (Courtesy of the *Meridian Star.*)

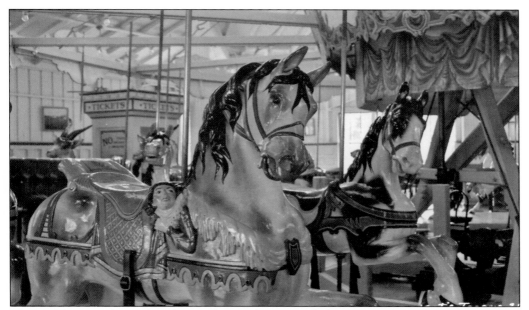

This 1896 carousel with hand-carved animals was made by Gustav Dentzel for the 1904 St. Louis Exposition. Meridian later purchased the carousel, and it arrived in 1909 and is located in the carousel house at Highland Park. Artist Rosa Regan of Raleigh, North Carolina, completed a carousel restoration project in 1995. This Dentzel carousel photograph by Katie Teague is on display at Weidmann's Restaurant. (Courtesy of Charles Frazier of Weidmann's.)

Curbside service awaits the hungry patrons at this barbecue stand. This building is located in the triangle of Seventeenth Avenue and Sixth Street in Meridian. (Courtesy of the *Meridian Star*.)

The Dentzel carousel house is located in Highland Park. (Courtesy of June Davis Davidson.)

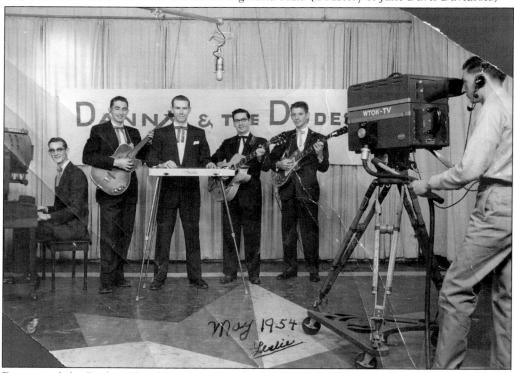

Danny and the Dudes, a local band, perform live on WTOK-TV in May 1954. From left to right are Vic Dawson (at the piano), Earl Aycock, Danny Holloway on the steel guitar, George "Skeeter" Gordon, and Autry Rutledge. WTOK-TV cameraman Leslie Hagwood films the performance. (Courtesy of Dorothy Hagwood.)

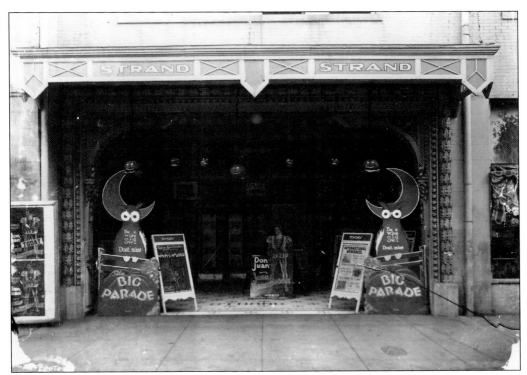

The Strand Theatre arcade displays a *Don Juan* movie poster around 1926. The theater opened in 1915 and closed in 1941 after it was damaged by fire. (Courtesy of the *Meridian Star*.)

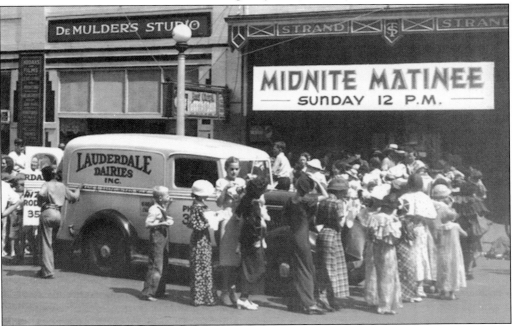

Lauderdale Dairies serves up ice cream to children at the Strand, and a banner advertises a midnight matinee. (Courtesy of the *Meridian Star*.)

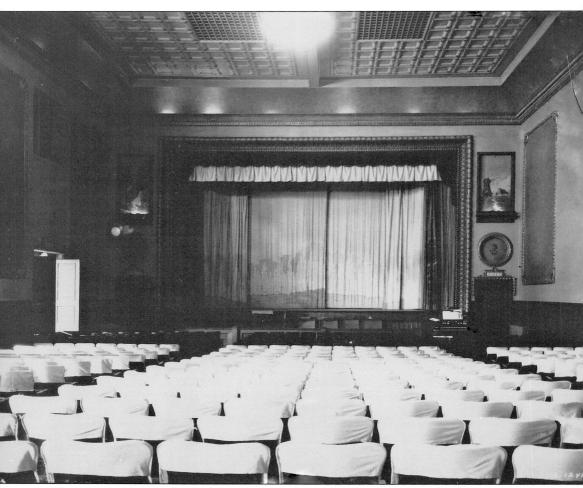

The interior of the Strand Theatre was cooled by fans located on each side. The seats were covered in linen for the comfort of patrons, as linen-covered chairs were thought to be cooler. A large clock stands near the edge of the stage at left. The Strand was one of several popular movie theaters in Meridian in the 1930s. The Strand Theatre was located at 814 Twenty-third Avenue. (Courtesy of William Hooper of Saenger Amusements.)

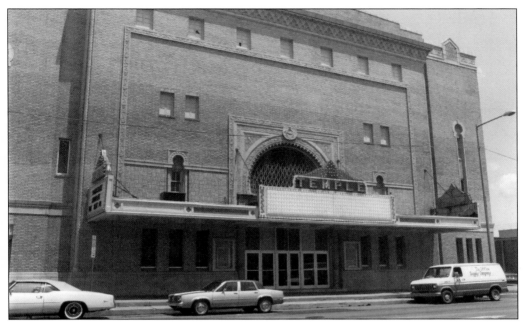

Construction began in 1923 on the Moorish Revival–style Hamasa Shrine Temple. The building was designed and decorated by architect Emil Weil and hailed as one of the most magnificent theaters in the South. At the time of construction, the theater's stage was the second largest in the nation. The beautifully appointed ballroom seated 500 guests. A lounge—for private functions—was located above the ballroom. The Temple Theater is located at 2320 Eighth Street. (Courtesy of Richelle Putnam.)

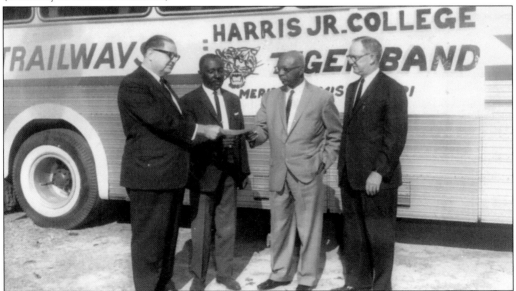

T.J. Harris Jr. College, an African American college, was a part of the segregated South until it merged by court order in 1970 with Meridian Community College. Pictured in center, from left to right, are C.E. Otis, band director of T. J. Harris High School, and Principal Walter J. Reed. (Courtesy of the *Meridian Star*.)

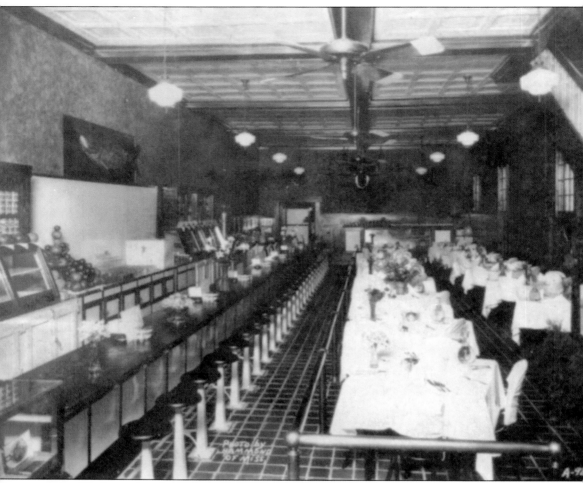

Felix Weidmann's café opened around 1870 and had remained in the Weidmann family for much of its 140-year history. It is well known for its black-bottom pie, ceramic peanut butter jars, and photograph-lined walls. Weidmann's is located at 210 Twenty-second Avenue. The restaurant has been renovated and is under new ownership. (Courtesy of the *Meridian Star*.)

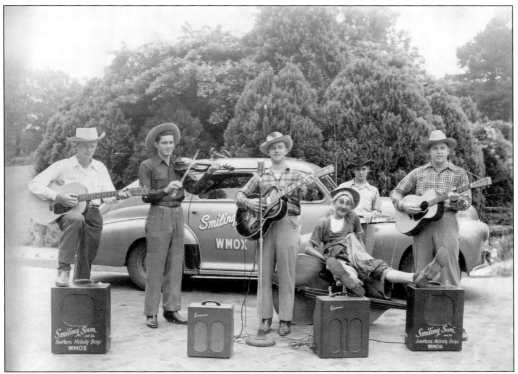

Earl Aycock (second from left) poses with the band Smiling Sam and his Southern Melody Boys. Aycock, a well-known radio personality and member of the "Breakfast Bunch," was the first person to visit Nashville and procure top entertainment for Meridian's Jimmie Rodgers Festival. (Courtesy of Mary Aycock.)

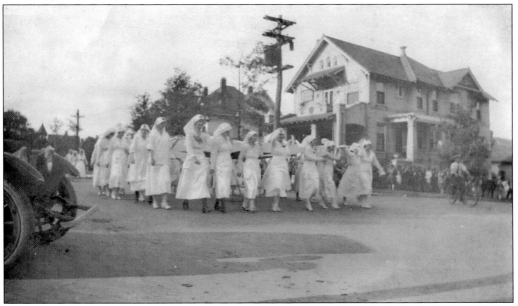

Nurses march in one of Meridian's many parades. (Courtesy of the *Meridian Star*.)

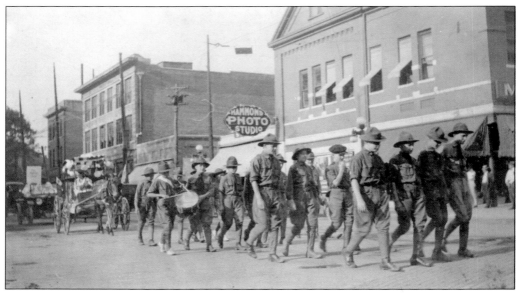

Uniformed paraders march in front of Hammond Studio in Meridian. (Courtesy of the *Meridian Star.*)

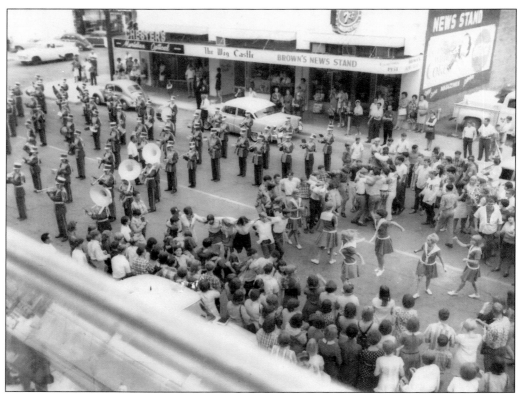

This photograph depicts a bird's-eye view of a marching band and cheerleaders in one of Meridian's many parades. (Courtesy of the *Meridian Star.*)

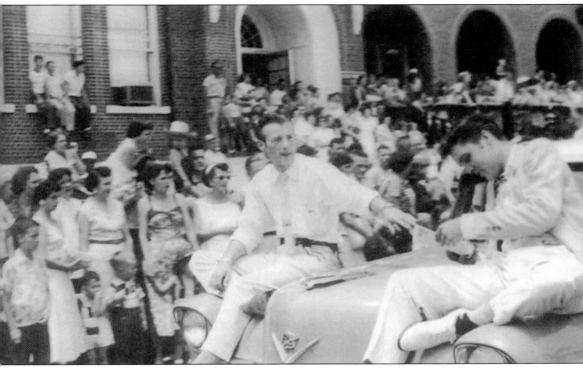

Elvis Presley, known as the "King of Rock 'n' Roll," was born in Tupelo, Mississippi. He appeared in Meridian's Calf Scramble Parade before he reached his height of popularity. (Courtesy of Lloyd Royal Jr.)

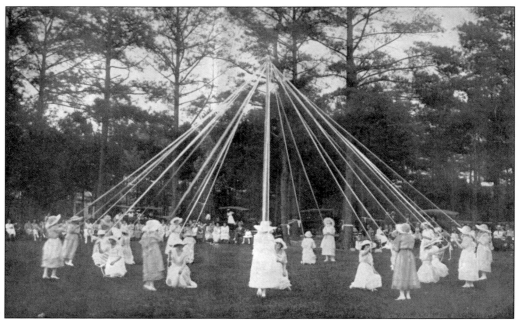

Young ladies in Meridian celebrate May Day by dancing around the maypole while holding colorful streamers in the early 1920s. (Courtesy of the Lauderdale County Department of Archives and History.)

This 1920s photograph depicts the queen's court during a May Day celebration in Meridian. (Courtesy of the Lauderdale County Department of Archives and History.)

Meridian's talented musicians perform at an unidentified theater about 1940. (Courtesy of the *Meridian Star*.)

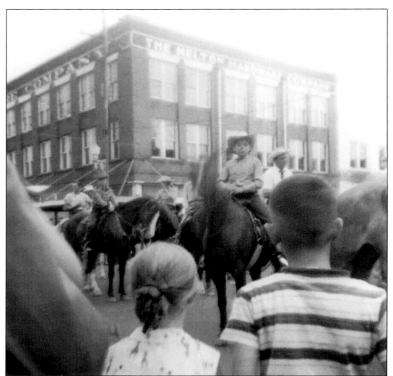

A young horseback rider is shown in the 1950s at one of Meridian's Calf Scramble parades. The Calf Scramble, once held at Ray Stadium, was a city and county event in which high school students roped and tied the hooves of a running calf. (Courtesy of Dolores Ratcliff.)

Sitting in front of the car is Delores Shirley, and Joan Anderson is standing to the right of her at Meridian's Calf Scramble at Ray Stadium on May 22, 1957. (Courtesy of Delores Ratcliff.)

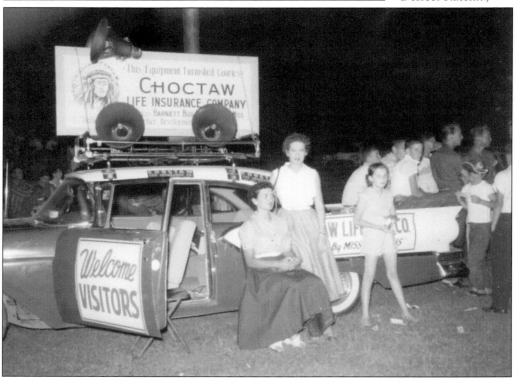

Five

IMPORTANT EVENTS

Meridian recovered from the economic impact of the yellow fever epidemic in 1879, a time when the town's rail system was ordered closed by the state. Fr. Lewis Valley worked tirelessly in Meridian to help those afflicted with yellow fever, a disease spread by mosquitoes raised in stagnated water.

At 6:30 p.m. on March 2, 1906, Meridian was struck by a tornado that destroyed hotels, restaurants, and businesses on Front Street and caused the deaths of many citizens, but the city would rise again.

Thirty-five trolley cars carried passengers over 10 miles of track from downtown to Highland Park, where visitors could enjoy outdoor concerts or stroll in the park. Meridian's citizens were lovers of education, and public schools and colleges sprang up. Using bond money, Meridian was the first city in the state to build a brick school for African American children. New brick buildings lined city streets as the horse and buggy faded away and automobiles took its place. In 1890, a poll tax of $2 was placed on voters, disenfranchising many of the poor. This poll tax was later repealed.

The eyes of the world were cast upon Fred and Al Key in 1935 as they flew the *Ole Miss* over the skies of Meridian to set a world record for flight endurance, staying aloft for 653 hours and 34 minutes. Local mechanic A.D. Hunter aided the flight and invented a spill-free air-refueling system.

Meridian was again thrust into worldwide news during the 1960s, when three civil rights workers—James Chaney, a young African American man from Meridian, and Andrew Goodman and Michael Schwerner, two Jewish civil rights activists from New York—were slain by Ku Klux Klan members near Philadelphia, Mississippi. Time has healed old wounds, and races have come together, steadfast in a vision to elevate Meridian to greatness once again.

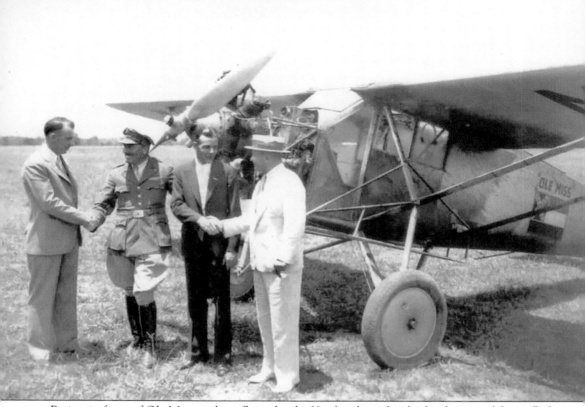

Posing in front of Ole Miss, a plane flown by the Key brothers that broke the record for in-flight hours, are (from left to right) Algene (Al) Key, Colonel Roscoe Turner, Al Key, and his brother, Fred. Fred received congratulations from Colonel Turner. The colonel, a barnstormer himself, broke the transcontinental speed with a 12 hour and 33 minute flight from New York to Burbank, California. Colonel Turner's career included working as stunt pilot in films. In 1952, Congress presented Turner with the Distinguished Flying Cross. Colonel Roscoe Turner was born September 29, 1895, in Corinth, Mississippi. The plane Ole Miss is housed at the Smithsonian National Air and Space Museum in Washington, DC. (Courtesy of the Lauderdale County Department of Archives and History.)

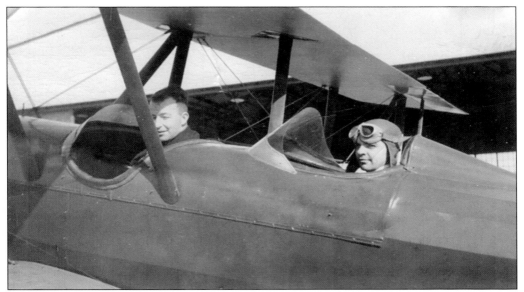

The Key brothers, Fred (left) and Al, are ready for takeoff. The brothers were barnstormers in the 1920s. (Courtesy of Sheila Hutcherson.)

Fred Key poses at Key Field. (Courtesy of Sheila Hutcherson.)

On June 4, 1935, barnstormers Al and Fred Key lifted off in a monoplane from Meridian Airport and stayed in the air for a record-breaking 653 hours and 34 minutes. The Key brothers logged 52,320 miles in the air before landing on July 1, 1935, in front of a cheering crowd. (Courtesy of the *Meridian Star*.)

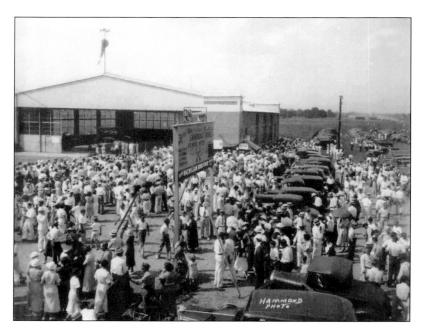

The Jimmie Rodgers Festival was once held at the Temple Theater on Eighth Street. Many popular singers and musicians have performed on the Temple Theater stage. (Courtesy of June Davis Davidson.)

James "Jimmie" Charles Rodgers was born in Meridian in September 1897. At a young age, he traveled with a medicine show. He married Carrie Williamson in 1920. Throughout his short career, he recorded over 100 songs, and by 1928, he was widely known as the "Singing Brakeman" for his occasional work as a railroad flagman and brakeman. He was diagnosed with tuberculosis in 1924 and passed away in 1933 because of the disease. (Courtesy of Virginia Irby.)

Young sailors are greeted at Union Station in this 1940s photograph. Union Station is located on Front Street. (Courtesy of the *Meridian Star*.)

The Trailways Bus Station and the Triangle Restaurant were located on Twenty-third Avenue. The back of the building faced City Hall. The Triangle Restaurant was well known for its Double Good Sandwich, which was made from veal. (Courtesy of Dolores Ratcliff.)

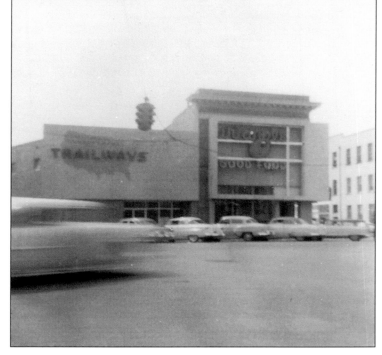

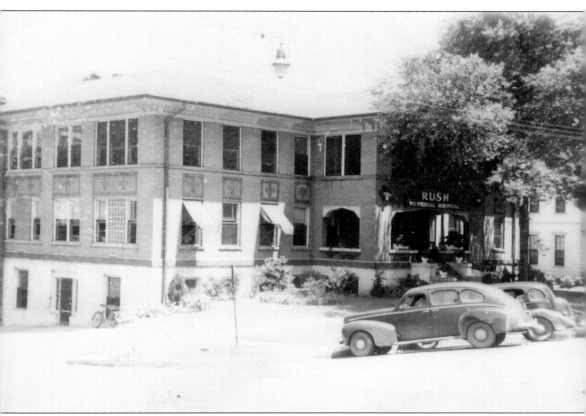

Constructed in 1915, Rush Memorial Hospital opened with a staff that included founder Dr. J.H. Rush, one registered nurse, and seven student nurses. Rush Memorial Hospital is located at 1314 Nineteenth Avenue in Meridian. In 1936, J.H. Rush's son Dr. Leslie Vaughn Rush performed the first pinning for a fractured bone. This surgery led to the development and use of an instrument known as the Rush pin. (Courtesy of Russell Keen.)

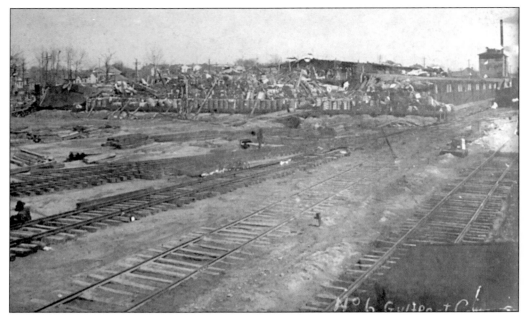

At 6:30 p.m. on March 2, 1906, a deadly tornado swept through Front Street, destroying two city blocks. The city lay in darkness without power or telegraph to summon help. In the heavy rain, searchers combed the debris in search of survivors. More than 30 people died as a result of the tornado. (Courtesy of the Lauderdale County Department of Archives and History.)

This photograph depicts a Memorial Day wreath-laying ceremony at the World War I Doughboy Monument dedicated on November 11, 1927, by the T.C. Carter American Legion Post No. 21. The monument is located at Dumont Plaza on Twenty-third Avenue, bound by Sixth and Seventh Streets. (Courtesy of the *Meridian Star*.)

Myrtle Estess (standing) pins a cap on a graduate of the Matty Hersee School of Nursing. During the 1950s, six hospitals existed in Meridian: Matty Hersee, Jeff Anderson's, Riley's, St. Joseph's, Rush's, and East Mississippi State Hospital. (Courtesy of the *Meridian Star*.)

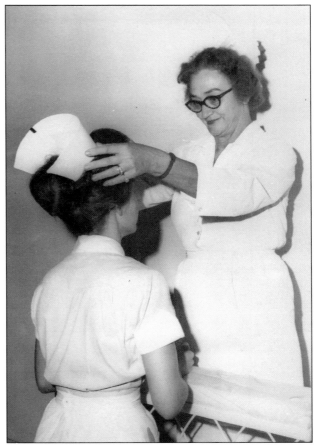

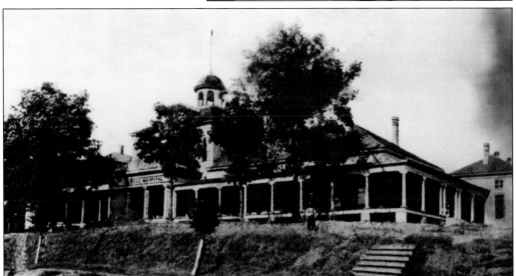

Matty Hersee Hospital was located on Popular Springs Drive in 1907. The hospital was organized in the late 1800s. (Courtesy of the Lauderdale County Department of Archives and History.)

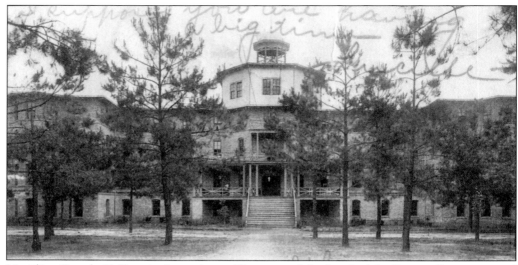

Meridian Female College is shown here. (Courtesy of the Lauderdale County Department of Archives and History.)

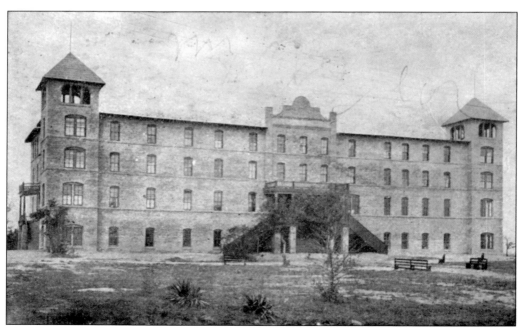

Meridian Male College is shown here. (Courtesy of the Lauderdale County Department of Archives and History.)

Pictured here are Robert Ray (left) and his brother Drew. Robert Ray was active in the civil rights movement in Meridian during the 1960s. (Courtesy of Robert Ray.)

James Dawson, pictured, was the first curator of the Lauderdale County Department of Archives and History located in the Raymond P. Davis Annex Building on Twenty-first Avenue. (Courtesy of the Lauderdale County Department of Archives and History.)

Jimmie Rodgers was known as the "Singing Brakeman" and the "Blue Yodeler." The Jimmie Rodgers Museum, filled with memorabilia from his career, is located at Highland Park. Rodgers's sister-in-law Elsie McWilliams wrote or co-wrote many of his songs. (Courtesy of June Davis Davidson.)

Pictured here is the Hotel E.F. Young Jr. on Fifth Street. E.F. Young Jr. was one of Meridian's first African American businessmen. He began his career as a barber to support his family. He used the knowledge he acquired as a barber to form the E.F. Young Jr. Manufacturing Company, which sells hair products across the world. (Courtesy of June Davis Davidson.)

A.D. Hunter, along with Fred and Al Key, invented a safe in-flight refueling system for planes. (Courtesy of the Lauderdale County Department of Archives and History.)

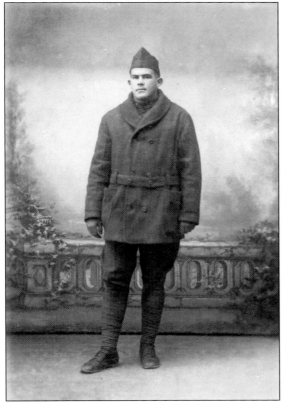

Chester Arthur Irby of Increase (now known as Causeyville) was born October 22, 1887, in Clarke County, Mississippi. The blue-eyed, brown-haired, medium-built native was employed as a rural mail carrier in Lauderdale County. When he registered for the draft, he was 29 years old, married, and had one child. Irby, shown in uniform, served in World War I. (Courtesy of Johnny Hughes.)

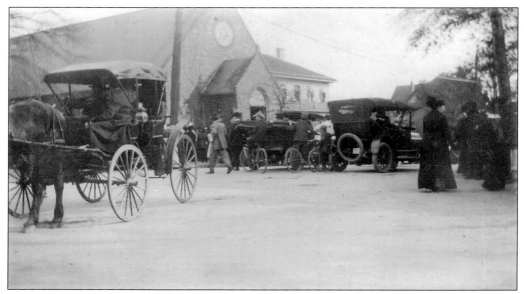

A large crowd gathers outside the church during the funeral of Kelly Mitchell, the Gypsy queen. Her body was taken to Rose Hill Cemetery on Eighth Street for interment. (Courtesy of the Lauderdale County Department of Archives and History.)

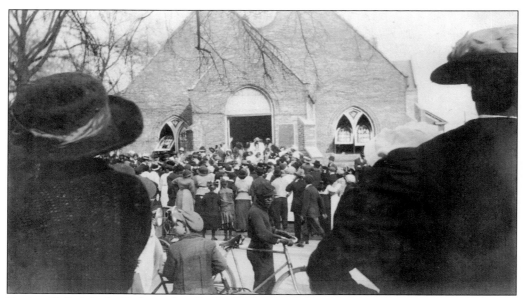

During Kelly Mitchell's funeral at St. Paul's Episcopal Church, two white horses and a hearse waited beside the church. Legend has it that over 5,000 people attended her burial at Rose Hill Cemetery. (Courtesy of the Lauderdale County Department of Archives and History.)

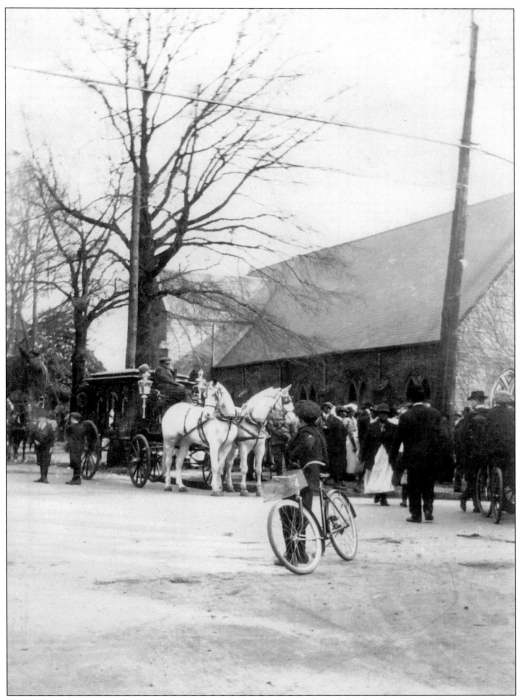

Two white horses and this hearse carried the body of Kelly Mitchell to Rose Hill Cemetery. Members of the Mitchell family still reside in Meridian. The cemetery is open daily, with the exception of Halloween. Early Meridian settler Lewis Ragsdale is also buried at Rose Hill, near the Mitchell grave sites. (Courtesy of the *Meridian Star*.)

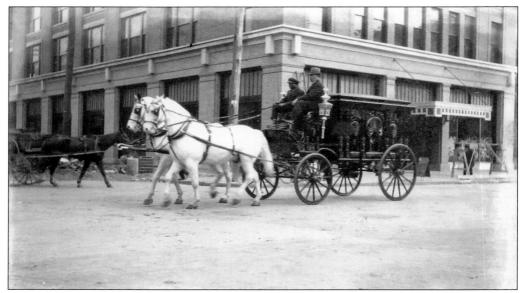

Gypsy queen Kelly Mitchell's hearse is pictured here, probably on its way to St. Paul's Episcopal Church. (Courtesy of the *Meridian Star*.)

The men inside this Gypsy wagon are dressed in suits. This may have been Emil Mitchell and his family. (Courtesy of the *Meridian Star*.)

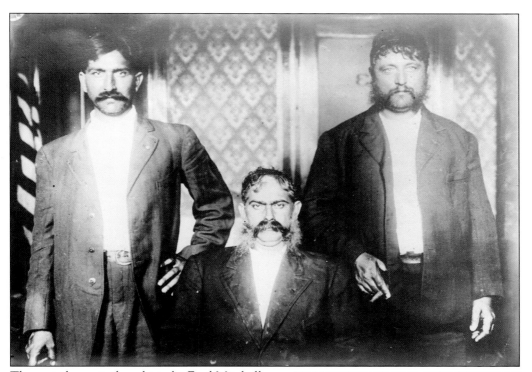

The seated man is thought to be Emil Mitchell. This photograph may have been taken at a Washington, DC, attorney's office, where documents were drawn up that named Mitchell "King of the Gypsies of North America." (Courtesy of the Library of Congress.)

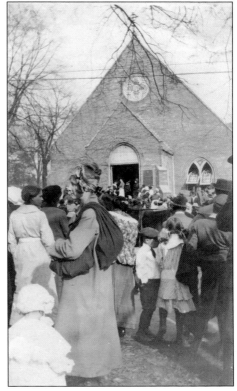

Hundreds of gypsies and others gather outside St. Paul's Episcopal Church for gypsy queen Kelly Mitchell's funeral in February 1916. (Courtesy of the Lauderdale County Department of Archives and History.)

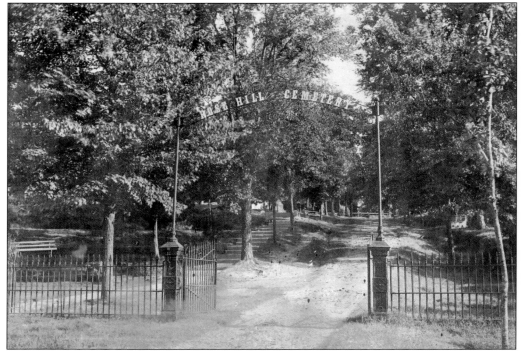

The main gate of Rose Hill Cemetery is pictured during the early 1900s. Rose Hill is one of the city's oldest cemeteries. John Ball and Lewis Ragsdale, two of the three founding fathers of Meridian, are buried at Rose Hill. The cemetery is located on Eighth Street. (Courtesy of the Lauderdale County Department of Archives and History.)

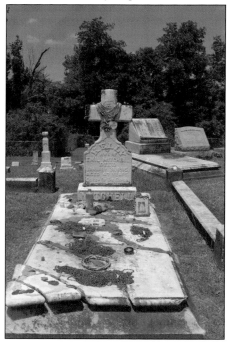

Visitors still leave offerings of food and gifts on Gypsy queen Kelly Mitchell's grave at Rose Hill Cemetery. Mitchell died while giving birth to her 16th child on January 31, 1915, in Coatopa, Alabama. Her body was brought to the Horace C. Well's Undertaking Company in Meridian. It is said that approximately 20,000 gypsies arrived in Meridian to attend her funeral, which was conducted on February 12, 1915, by Rev. H.C. Wells of St. Paul's Episcopal Church. (Courtesy of June Davis Davidson.)

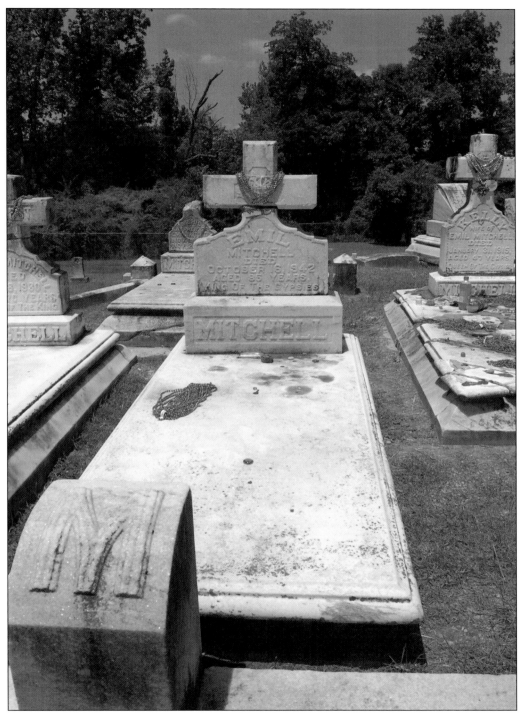

Gypsy king Emil Mitchell is said to have been seven feet tall, with a white beard. He died in Albertville, Alabama, on October 16, 1942. He is buried next to his wife, Kelly, at Rose Hill Cemetery. (Courtesy of June Davis Davidson.)

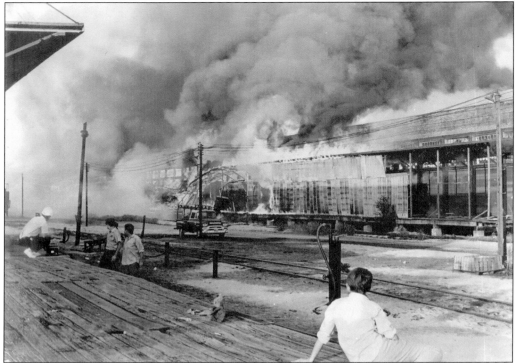

Billows of black smoke rise above Front Street during a 1963 fire. The buildings on the south side of Front Street bordered the railroad. The fire was located between Twenty-second and Twenty-third Avenues on Front Street. Meridian has been the scene of many fires. (Courtesy of the *Meridian Star.*)

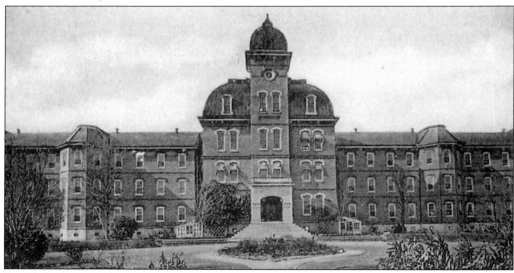

Established in 1882 by an act of the Mississippi Legislature, this building was known as the East Mississippi Insane Asylum until the named changed to the East Mississippi State Hospital in the 1930s. The facility is still open and currently serves 31 counties in Mississippi. (Courtesy of the Lauderdale County Department of Archives and History.)

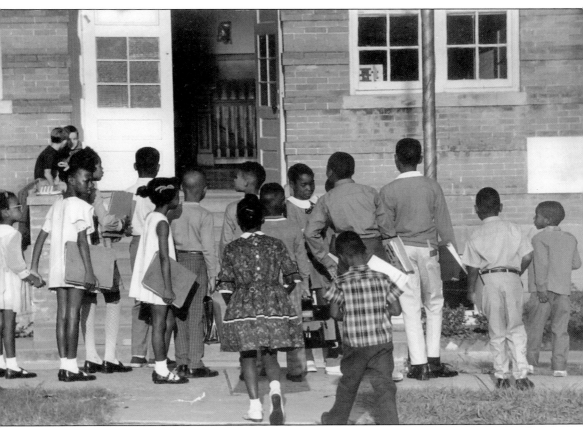

Racial segregation ended in Mississippi in the 1960s, bringing about an end to poll taxes, as well as separate water fountains, public facilities, schools, restrooms, and waiting rooms. Lauderdale County schools integrated peacefully. (Courtesy of the *Meridian Star*.)

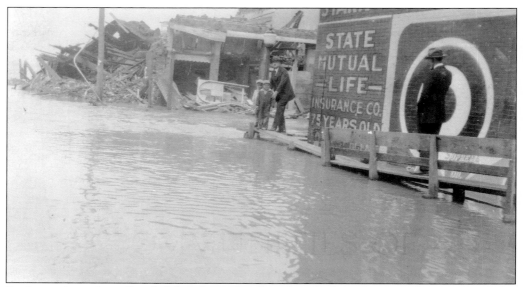

Spring rains often flooded low-lying land in Lauderdale County. (Courtesy of the *Meridian Star*.)

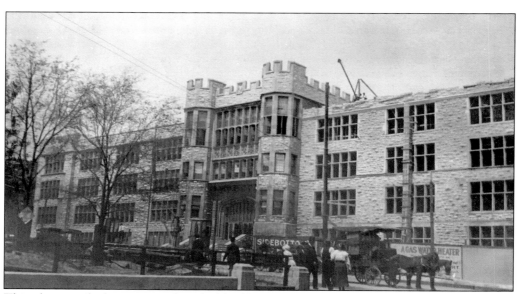

This photograph shows an unidentified building thought to be in Meridian in its early years. Advertising signs, such as "Sidebottom" on the carriage and "Gas Water Heater" on the board near the building, are visible. (Courtesy of the *Meridian Star*.)

Six

COMMUNITIES OF LAUDERDALE COUNTY

Many current Lauderdale County residents are direct descendants of early settlers. In the 1800s, Lauderdale County communities provided education for their children by building one-room schools. Some of these communities are now extinct, while others still exist.

Photographs of many of these schools were originally published in 1922. Sageville, Toomsuba, Liberty, Schamberville, and Valley schools at Meehan relied on the outhouse, as well as creek water or a dipper and water bucket drawn by rope from a shallow well to quench thirst. This was an era when a school lunch, packed with a biscuit and fried fatback, was carried to school in a bucket. At the end of the school day, students often ate a cold biscuit filled with molasses for an after-school snack.

The settlers built churches and general stores, where farmers could buy farm implements and seeds for planting and women could buy material for hand-sewn dresses. The community general store often had a gristmill where farmers brought corn for milling into cornmeal and grist, both Southern staples.

Farm families relied on the general store for necessities during the mid-1800s to the early 1900s. T.J. Bostick, a native of North Carolina, arrived in Lauderdale County shortly after the Civil War. He settled in the sparsely populated community of Causeyville and built a general store. Bostick allowed Native Americans from Alamuchee, a Choctaw village just southeast of Causeyville, to sell herbal medicines at his store. Causeyville was once known as Ebony and Increase. Bostick also built the current store, now called Causeyville General Store, before 1900. Over the past 70 years, the store has been the office of Dr. W.J. Anderson (who was referred to fondly as "Dr. Billy"), a weekend movie theater, a soda fountain, and a post office. Under the name Ebony and Increase, the T.J. Bostick store and gristmill were located adjacent to the current general store.

The Kewanee Simmons-Wright Company is a century-old general store that once operated a cotton gin and gristmill. Cotton and cattle were shipped by rail from the Kewanee Depot.

Other communities—such as Bailey, Center Hill, Lauderdale, Whynot, Russell, and such—have played an important role in the development of the county.

The communities of Lauderdale County, consisting of a valuable workforce and business owners, are the area's greatest assets.

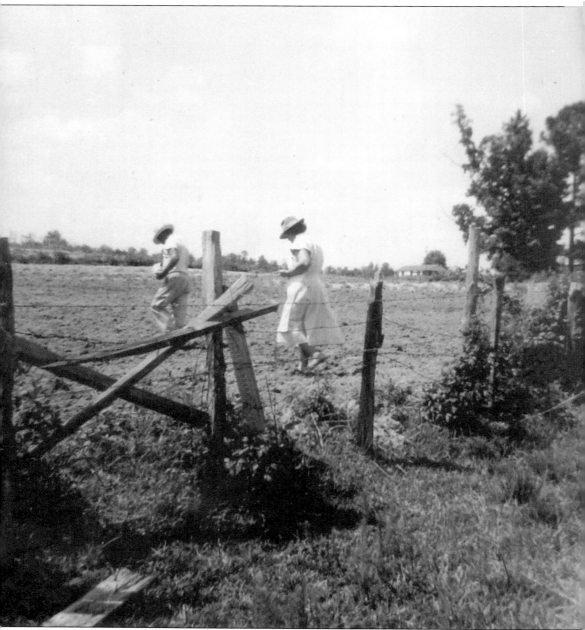

Sam and Maude Davidson sow seeds in tilled soil. Many families in surrounding counties shopped in Meridian. (Courtesy of Dolores Ratcliff.)

Carlos Seth Fountian (far right) and his wife, Mary "Tella" Estelle (far left), and children lived in Hurricane Creek in Lauderdale County before 1920. Carlos was born on February 13, 1860, in Clarke County, Alabama. According to the 1920 federal census, Carlos Seth and Mary Estelle Day Fountian had one child remaining at home, 16-year-old Willie E. Fountian. (Courtesy of Johnny Hughes.)

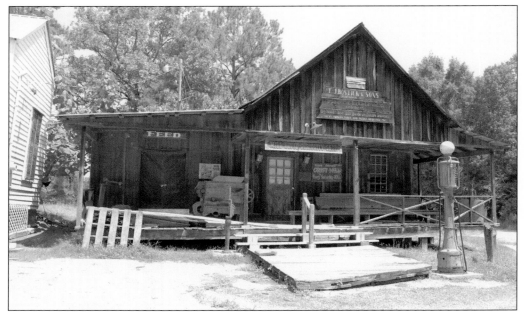

T.J. Bostick's general merchandise store was established in the late 1800s. Bostick came to the area shortly after the Civil War. Later, Bostick built a larger store, now known as Causeyville General Store. Both stores are located side by side in the Causeyville community, nine miles south of Meridian on Causeyville Road. (Courtesy of June Davis Davidson.)

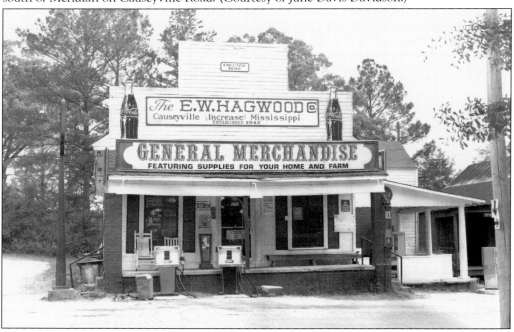

The Causeyville General Store has been in the Hagwood family for 50 years of its 102-year history. At different times, the store housed a post office, a weekend theater, a soda fountain, and the office of Dr. William Anderson. Vintage movie posters, player pianos, and other antiques are on display within the store. (Courtesy of June Davis Davidson.)

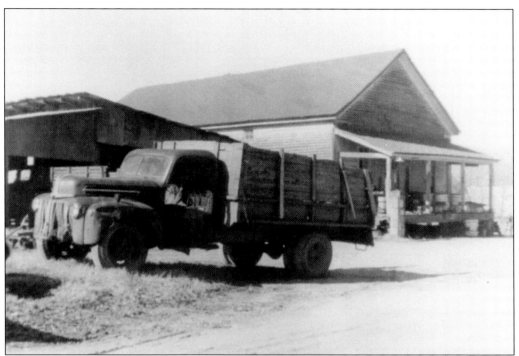

Joseph Thornton Gunn built the general store at Topton in 1905. The store, no longer in operation, was located beside the railroad track on Topton Road. Gunn, a grocer, also sold farming supplies. The store served as a voting precinct and a commissary for the J.B. Gunn Cotton Farm. (Courtesy of Harland Davis.)

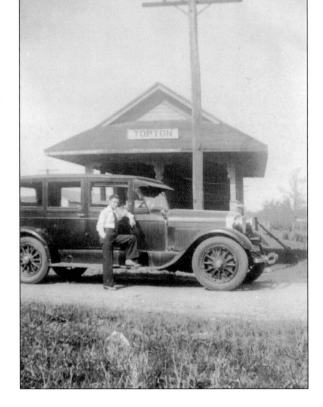

J.B. Gunn Jr. is shown standing next to an automobile at the Topton Train Depot in 1934. The former Gulf, Mobile & Ohio (GM&O) Depot was located near Joseph Gunn's general store. Topton passengers could ride the *Doodlebug* train to Meridian. (Courtesy of Harland Davis.)

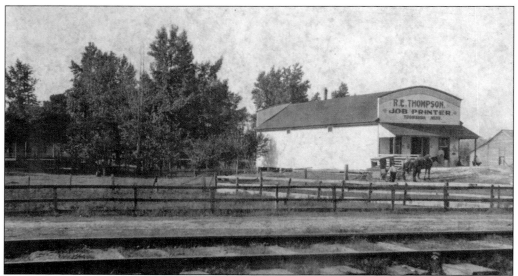

The R.E. Thompson Print Shop in Toomsuba is pictured in the early 1900s. (Courtesy of Emma Lou Price.)

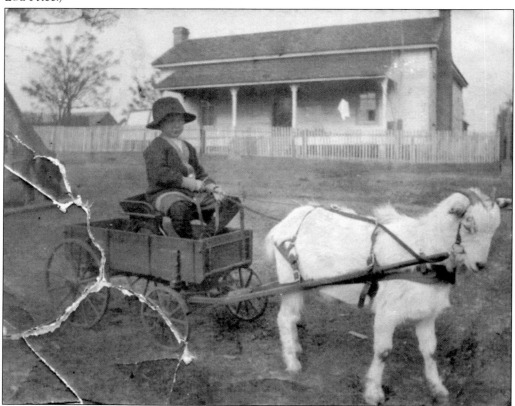

Charles Mayerhoff enjoys a bit of "goat-carting." Tom Walkers, rope swings, and jump ropes were the toys of the day. Older children rode horses and swam in nearby creeks. Children attended dinner on the ground with their parents at church. (Courtesy of Mary Ruth Bordron.)

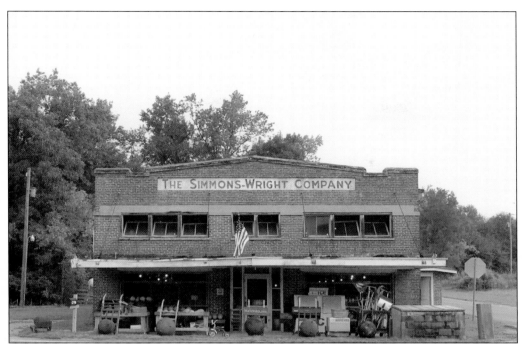

The Simmons-Wright Company is a general merchandise store established in 1884 by William Simmons and Tom Wright. A cotton gin, gristmill, and blacksmith shop served the community of Kewanee. The original store was destroyed by fire in 1926 and rebuilt the same year. Simmons-Wright Company is located at 5493 Highways 11 and 80 in Kewanee. (Courtesy of June Davis Davidson.)

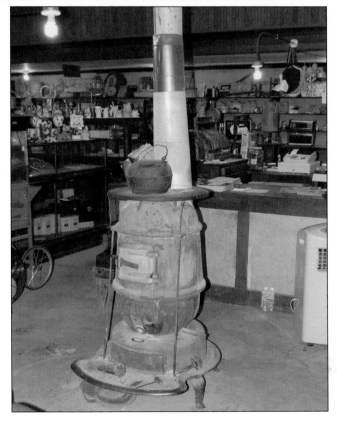

An old potbellied stove at the Simmons-Wright Company speaks of days of iron wash pots and shoes dating back to the 1940s. The back of the store faced the old Dixie Highway, on which cattle, produce, and ginned cotton was shipped by rail from Kewanee Depot. (Courtesy of June Davis Davidson.)

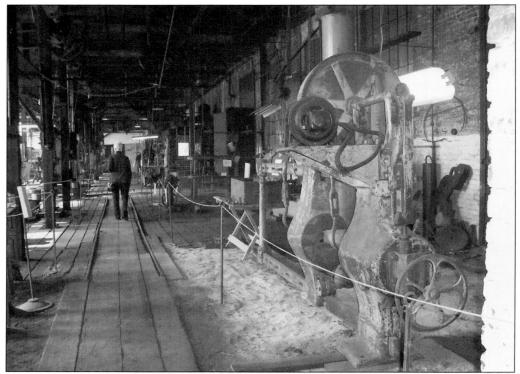

This photograph shows the boarded walkway inside Soulé Steam Feed Works. A large eight-foot safe with the Soulé name etched in gold is in one of the adjoining rooms, along with an early-1900 workmen's restroom that has not been restored. (Courtesy of June Davis Davidson.)

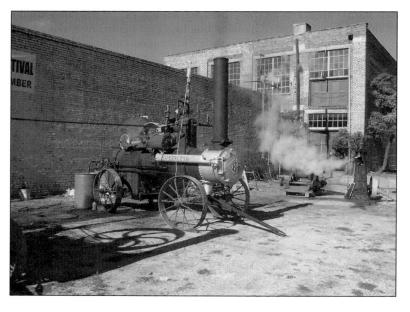

George Soulé founded Soulé Steam Feed Works in 1891. Soulé served the timber industry from 1892 through the mid-1950s, using portable steam as a source of power. Soulé is located at 402 Nineteenth Avenue. (Courtesy of June Davis Davidson.)

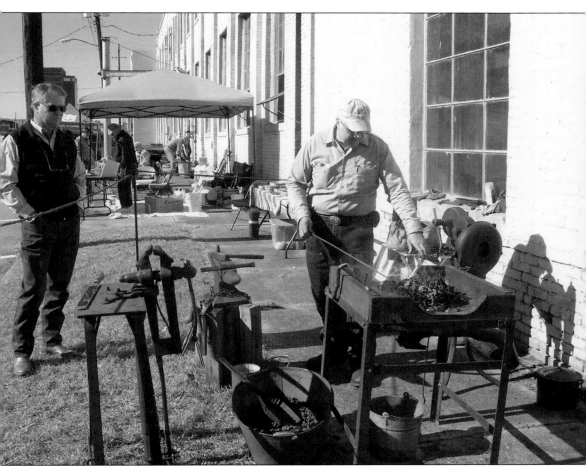

Soulé Steam Feed Works' annual festival displays steam engines inside the Soulé building. In this photograph, a craftsman uses coal and an anvil to demonstrate how to make a nail. During the festival, Soulé blows a steam whistle throughout the day. (Courtesy of June Davis Davidson.)

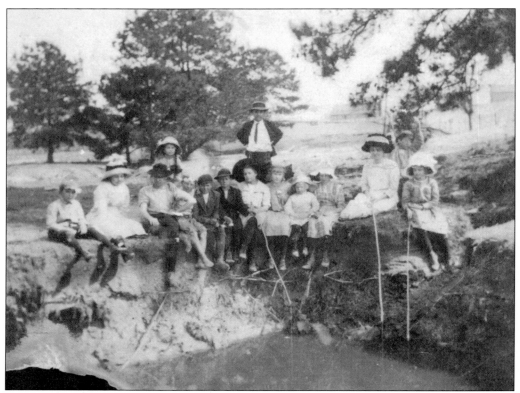

Local children fish in Lon Price's pond in Toomsuba around 1910. Pictured here are, from left to right, Leander Price, unidentified, Clarence Price, unidentified (standing), unidentified, John H. Cameron, Lester Price, Adrian McLaurin, Janie Satcher, Christine Price, unidentified (standing), unidentified, Toomsuba schoolteacher Mary Welch, and an unidentified girl and boy (standing). (Courtesy of Emma Lou Price.)

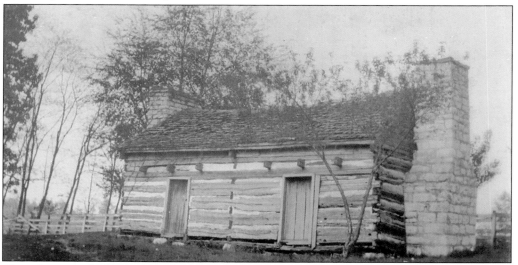

This photograph shows an unknown settler's hand-hewn log home in Lauderdale County. (Courtesy of the *Meridian Star*.)

A young boy tends his goat.
(Courtesy of the *Meridian Star*.)

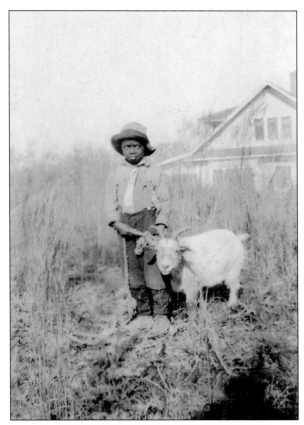

Able-bodied members of farm families harvested crops. Young children used 25-pound feed or flour bags as picking sacks. (Courtesy of Dr. Annie Sagen; photograph by Arthur Rothstein.)

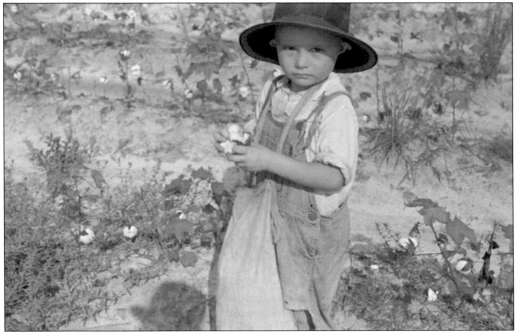

This school served the community at Suqualena, which was northwest of Meridian in Lauderdale County. The post office was moved from Collinsville to Suqualena sometime between the late 1800s and early 1900s and then transferred back to Collinsville, where it remained. (Courtesy of the Lauderdale County Department of Archives and History.)

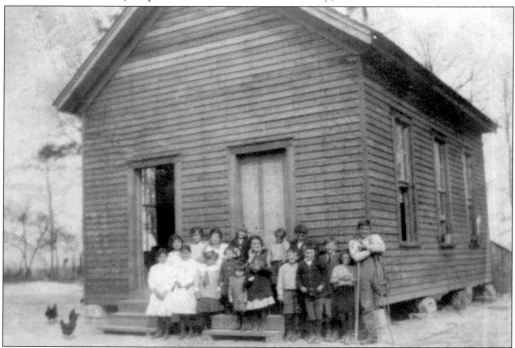

Sageville School was one of many one-room schools scattered across Lauderdale County before 1900. (Courtesy of Mary Ruth Bordron.)

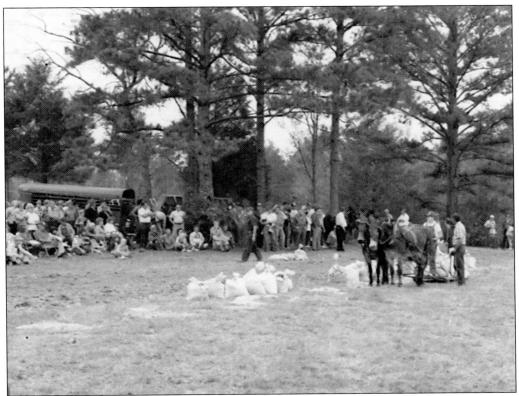

This photograph shows a mule pull at Causeyville Day around 1985. Causeyville is located nine miles south of Meridian on Causeyville Road. Causeyville Day began in the 1980s. (Courtesy of Dorothy Hagwood.)

Members attend the Causeyville Baptist Church around 1950. The Ebenezer Cemetery is located to the southeast of the back of the present-day church. The cemetery can be accessed from concrete steps located on Causeyville Road, just north of the store. (Courtesy of Johnny Hughes.)

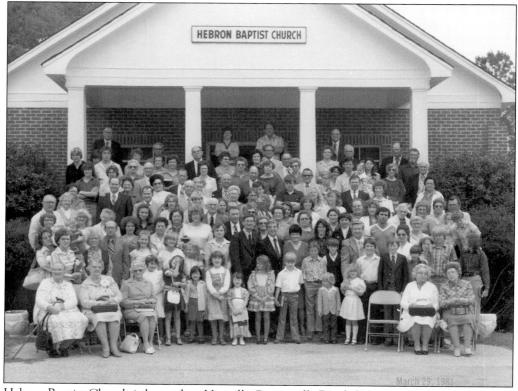

Hebron Baptist Church is located on Vimville Causeyville Road. (Courtesy of Ann Robinson.)

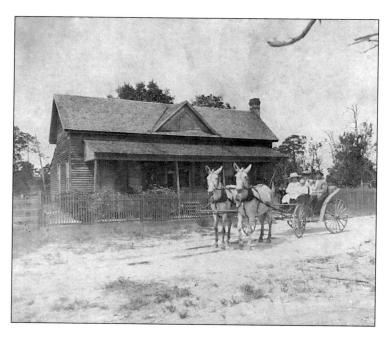

In this 1910 photograph, the Irby family heads to Sunday morning church service. From left to right are (up front) Preston, Mary, and Willard; (in the back) Maggie, Agnes, and Morgan. Maggie Coker Maggard and Morgan William Irby married on October 13, 1895, in Lauderdale County. Morgan, a farmer, built the Irby home shortly after the wedding. (Courtesy of Doris Welker.)

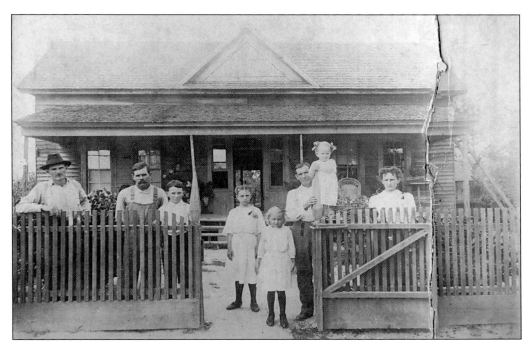

The Morgan William Irby house, a typical dogtrot home of the late 1800s, is located on the Vimville Causeyville Road in Lauderdale County. Pictured here are, from left to right, Tom, Jinx, Preston, Mary, Morgan, Willard, Agnes (on fence), and Maggie. (Courtesy of Doris Welker.)

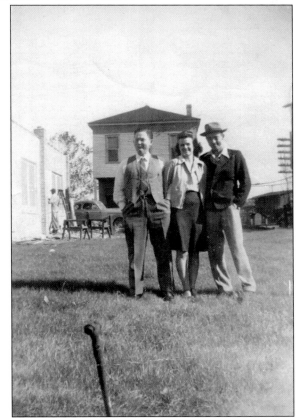

Northeastern Railway employees Frank Ming (left), Virginia Culpepper Irby (center), and Cecil Steven pose for a snapshot in front of the railway office. Irby's husband, Paul, served in the Army during World War II. (Courtesy of Virginia Irby.)

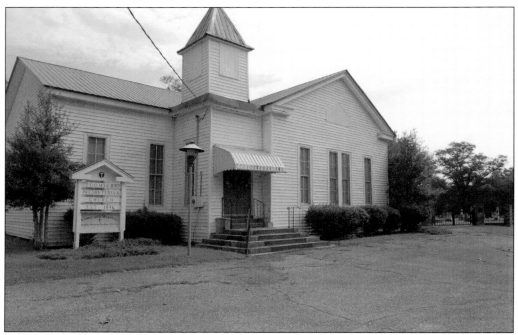

Toomsuba Presbyterian Church was formed in 1836. Toomsuba is one of the oldest communities in Lauderdale County. After he burned Meridian, Gen. William Sherman destroyed the railroad in Toomsuba. The community is near the Alabama state line on Highways 11 and 80 East. (Courtesy of June Davis Davidson.)

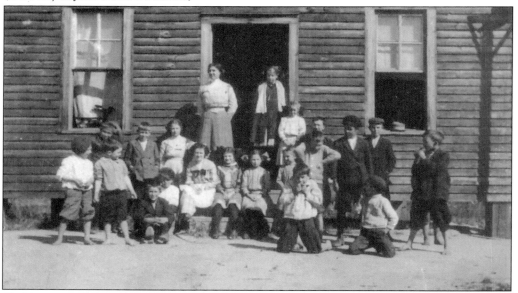

Children attend a one-room school in Toomsuba. Some of the children identified in this image are "Shug" Price, Leander Price, Adrian McLaurin McAlister, and Lillie Maude Saxon. The boy kneeling second from the right is Harmon Price, eating an orange. Other children are unidentified. In the doorway is Toomsuba schoolteacher Mary Welen. The school was located on the Lauderdale Toomsuba Road. (Courtesy of Emma Lou Price.)

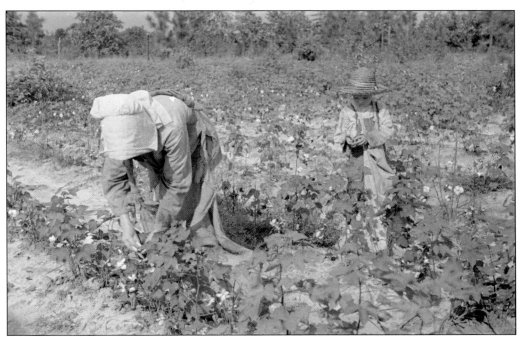

This photograph shows a typical scene on Lauderdale County farms in the early 1900s. (Courtesy of Dr. Annie Sagen.)

Income from the sale of cotton provided money for necessities for Lauderdale County farmers. (Courtesy of Dr. Annie Sagen.)

Students and teachers of the Causeyville Consolidated School are pictured before the school was demolished in the 1950s. The school was located on the corner of Causeyville Road and the Causeyville Clarke Road. (Courtesy of Johnny Hughes.)

Seen here is an unidentified group of children at Causeyville Consolidated School. (Courtesy of Johnny Hughes.)

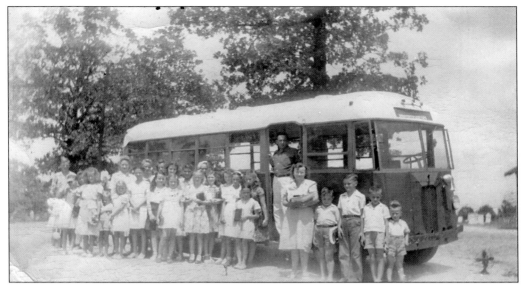

Charlie Shirley, a member of Long Creek Baptist Church, drove the church bus that carried children and adults without transportation to and from church services. Charlie Shirley is standing in the doorway of the old city bus purchased by Long Creek Baptist Church. (Courtesy of Delores Ratcliff.)

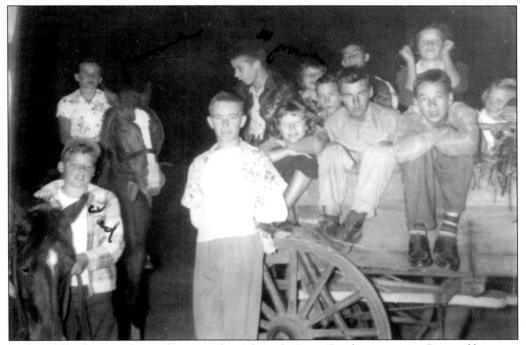

In this 1950s photograph, youths enjoy a hayride in the Long Creek community. Pictured here are, from left to right, Fred Covington, Jimmy Lilly (on horseback), J.L. Rawson (standing in front of the wagon wheel), Bobby Ray Ellis (boy with his feet on the wagon wheel), Everett Sellers (next to Bobby Ray, with folded arms), and behind Sellers is Eddie Ann Raley (with hands raised) and other unidentified children. (Courtesy of Delores Ratcliff.)

This is Toomsuba in 1929. Shown at far left is the Ander Price store, and next to the Ander Price store is a store owned by Bob Charles. In the background on the right is the Ander Price house. The store on the right side of the road belonged to Lester Price. (Courtesy of Emma Lou Price.)

The Calf Scramble was a large event in Meridian during the mid-1900s, when the Future Farmers of America was a popular organization for Lauderdale County students. An unidentified local Lauderdale County high school student throws and ties a calf during Meridian's Calf Scramble. (Courtesy of the *Meridian Star*.)

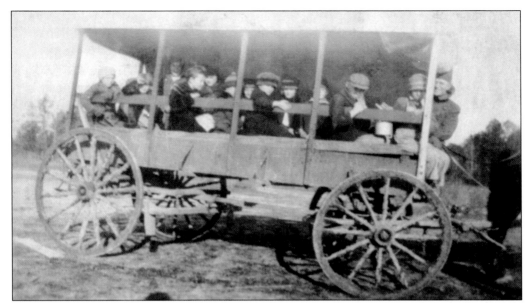

Will Pigford took children to school by horse and wagon on Smith Spur Road. In the late 1800s, wagons were used to transport rural children to school. (Courtesy of Emma Lou Price.)

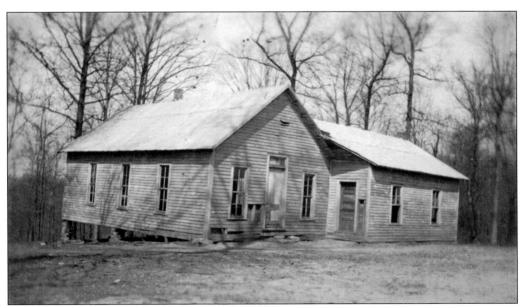

This former school for African American children at Pleasant Grove on the Lauderdale Toomsuba Road is now the home of Head Start, a preschool program for area children. (Courtesy of Emma Lou Price.)

Pictured in the doorway of Long Creek School are math teacher Mattie Fern Light (left), English literature teacher Mrs. Culpepper (center), and science and chemistry teacher Mrs. Sanford. (Courtesy of Dolores Ratcliff.)

In this 1940s photograph, workers concentrate in the Ross Collins Vocational Center at 2640 Twenty-fourth Avenue. The center opened in 1942, during World War II, and is still in operation. (Courtesy of the Ross Collins Vocational Center.)

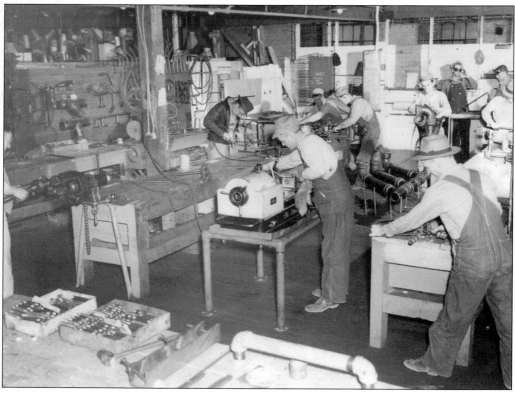

Television repair was a class at Ross Collins Vocational Center when televisions had large glass tubes and programs were shown in black and white. (Courtesy of the Ross Collins Vocational Center.)

DISCOVER THOUSANDS OF LOCAL HISTORY BOOKS
FEATURING MILLIONS OF VINTAGE IMAGES

Arcadia Publishing, the leading local history publisher in the United States, is committed to making history accessible and meaningful through publishing books that celebrate and preserve the heritage of America's people and places.

Find more books like this at
www.arcadiapublishing.com

Search for your hometown history, your old stomping grounds, and even your favorite sports team.